Capturing the French River

Images Along One of Canada's
Most Famous Waterways, 1910–1927

WAYNE KELLY

NATURAL HERITAGE BOOKS
A MEMBER OF THE DUNDURN GROUP
TORONTO

Published by Natural Heritage Books
A Member of The Dundurn Group
3 Church Street, Suite 500
Toronto, Ontario, M5E 1M2, Canada
www.dundurn.com

Library and Archives Canada Cataloguing in Publication

Kelly, Wayne, 1947-
Capturing the French River : images along one of Canada's most famous waterways, 1910-1927 / Wayne Kelly.

Includes bibliographical references and index.
ISBN 978-1-897045-23-7

1. French River (Parry Sound, Ont. : River)—Pictorial works. 2. French River (Parry Sound, Ont. : River)—History. I. Title.

FC3095.F7K45 2007 917.13'1500222 C2007-902223-5

1 2 3 4 5 11 10 09 08 07

All visuals from the Rushbrook-Sherman Collection unless otherwise indicated.
Cover design by Neil Thorne
Text design by Sari Naworynski
Edited by Jane Gibson
Printed and bound in Canada by Tri-Graphic

Canada Canada Council Conseil des Arts
 for the Arts du Canada

40 YEARS ★ 40 ANS

ONTARIO ARTS COUNCIL
CONSEIL DES ARTS DE L'ONTARIO

We acknowledge the support of the Canada Council for the Arts and the Ontario Arts Council for our publishing program. We also acknowledge the financial support of the Government of Canada through the Book Publishing Industry Development Program and The Association for the Export of Canadian Books and the Government of Canada through the Ontario Book Publishers Tax Credit Program and the Ontario Media Development Corporation.

J. Kirk Howard, President

For my wife, Jeannie.
My favourite canoe partner;
my best friend.

Contents

Acknowledgements

Many individuals and institutions have been of great assistance with regard to providing information, text materials and support for this project. Among them are: Dr. Paul Carey, past president, World Federation of Chiropractic; Alan Dhingra, Canada Post; Caleb G. and Tameka Kelly; Van and Susan Montgomery; John and Jessica Soares; Stewart and Ruth Kelly; Pat and Joe D'Agostino; Metropolitan Toronto Reference Library; Royal Ontario Museum, Toronto; Parry Sound Public Library; London Public Library; Stratford Public Library; Barry and Lee Gallerno; Bernard Beard; Andrew Phillips, Mountain-Mitchell Barristers and Solicitors, Stratford; John McKittrick, McKittrick's Cameras Ltd., London; Roland Schubert, Colour By Schubert, London; the staff at French River Trading Post; Kirk Wipper; Canadian Canoe Museum, Peterborough; Randy Rysdale, Yesterday's Lodge, French River; French River Resorts Association; French River Visitor's Centre; René's Cruises, Wolseley Bay; and the two guys (whose names I neglected to get) who strolled up to me with a skinned beaver in a wheelbarrow one afternoon at Hartley Bay, and invited me to stay for supper.

I am also very much indebted to the kindly patience and sage advice provided by my publisher, Barry L. Penhale, and my editor, Jane Gibson, without whose talents and experience this project would have been so much more challenging.

But of most assistance, and without whom this wonderful collection of Canadian photographs would not have been preserved, is Mrs. Ruth Beard.

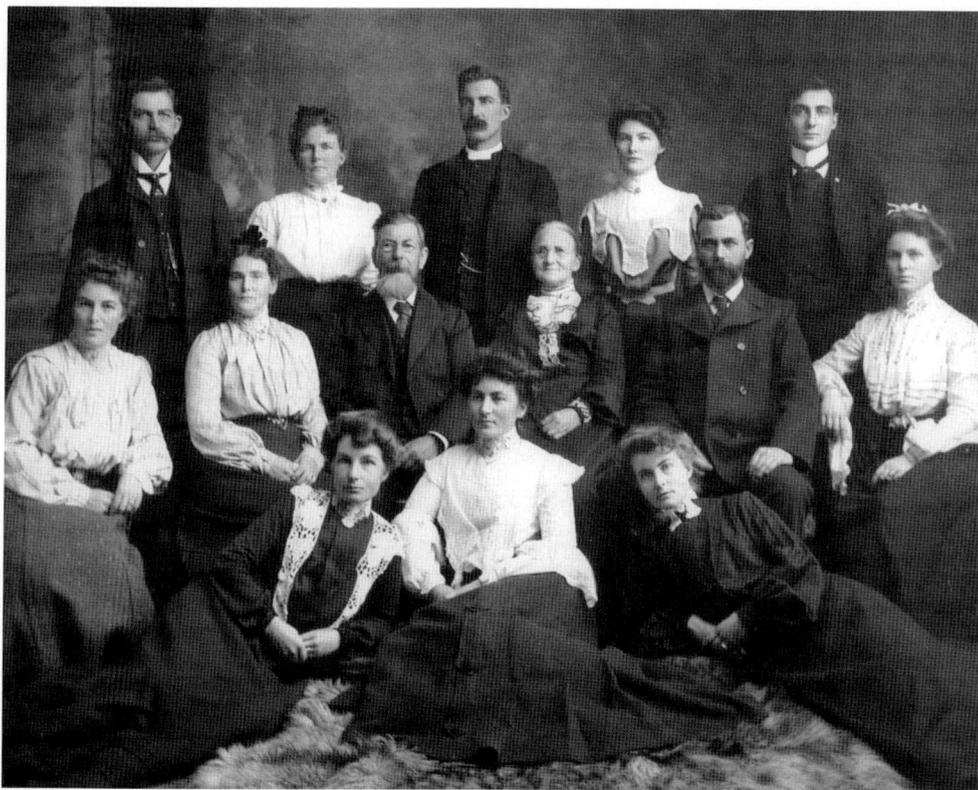

The family of George and Eliza Rushbrook of Toronto, Ontario, photo dated December 25, 1903. From left to right (back row): William, Lottie, Walter, Ethel, Ernest; (middle row) Ida, Alice, George Sr., Eliza, George Jr., Lucy; (front row) Helen, Bertha, Marion. While it is not improbable that a commercial photographer in 1903 may have worked on Christmas Day, it might also be possible that Ernest, who had by this time been developing his photographic skills for close to ten years, may have arranged the family members and taken the shot with his large-format view camera, using a timer device or remote shutter release to capture the image.

Introduction

A people without history is like the wind on buffalo grass.
– anonymous Sioux saying

The snow-white hair of the 84-year-old woman who stood before me framed a pair of bright, intense eyes; eyes that danced with character, intelligence and life.

"I had two knee replacements done a while back. And they forced me to have a pacemaker installed just a few weeks ago. But I'm not going to let that slow me down," said a confident, yet soft, voice.

"My name is Ruth Beard," said the woman. "Your mother told me you might be interested in seeing my pictures."

While there have been few of my parents close friends and acquaintances that I have not known well, Ruth Beard had previously been familiar to me in name only. Taking my arm and raising it toward her, Ruth pressed a small, picture postcard into my hand. The photographic image on the face of the card was extremely clear, well-composed and relative to a topic that appealed to me. On the reverse side, a red, two-cent, Canadian stamp bearing the likeness of King George V in the upper right corner defined the era. And while the exact date contained within the postage cancellation mark was somewhat blurred, the name of the issuing office was not. "French River, Ontario." The postal date did not matter since the

author of the words inked onto the left side of the postcard had carefully penned "August 8, 1915" above the salutation and greeting that followed:

> Dear Mother & all,
> It is cool tonight. We were up at the big rapids today and caught 14 pickerel, 3 pike and a big catfish about 10 or 12 lbs. Young Max is having a fine time. There are no blueberries here but we have picked a lot of raspberries. Have five jars of jam so we will have some fruit to fend us through. We are all well and enjoying ourselves. Love to all from all, Ernest.[1]

Another postcard was committed to my hands. Another and another, as each in turn was withdrawn from the woman's purse.

"My father, Ernie Rushbrook, and my Uncle Frank took these pictures up at the French River," Ruth exclaimed, with a tone that scarcely hid the sound of pride and a timbre that begged to get my response to the age-old images.

It was close to dusk. Ruth and I stood in the fading light that filtered through the whiteness of the large tent that had been erected in the backyard of my parents' home. Their sixtieth wedding anniversary party was an event that my three sisters and I had carefully orchestrated for many weeks in advance. So as not to tax our octogenarian parents with too much activity, we had planned the party to span three days. Tonight, Friday, was to be an open-house invitation for the entire community in which they lived. Saturday and Sunday would be just for family. As the still, golden evening carried the scent of August corn upon the air, a surprising number of folks from the small, rural-Ontario town made their way to the celebration. Something about that evening was warm, comforting, reassuring. Sharing even a few moments of eye contact and the exchange of friendly words with good people that I had not seen for several decades was a rare and delightful experience.

"I have a couple of thousand of these pictures." Ruth's voice tumbled up to my ear drawing me demandingly back to our conversation and the sepia-coloured images that obligated my attention.

The photographs were nothing short of mesmerizing. Early twentieth century scenes of men, wearing shirts and ties, and women, bedecked in long dresses, paddling canoes through churning plumes of white water; stringers bearing as many as two dozen fish, proudly held aloft by anglers with beaming smiles; idyllic views of shore-side camps replete with the activities of wood chopping, fire tending and cooking the day's catch. But I was the one who was now hooked.

"When can I see the rest of your collection?" I asked.

An appointment at Ruth Beard's home the following week and the opportunity to finger through just a small portion of her family photograph collection far exceeded anything I had imagined. Scarcely able to speak words of excitement or surprise as my host monopolized the conversation entirely, Ruth placed stack after stack of aged pictures in front of me, and opened my mind to story after story of her family history as the photos, documents, paintings and artifacts were laid out before me. I was in history heaven.

The following week, as I dipped my paddle into the still, morning waters of Lake Nipissing's West Arm, my thoughts kept rippling back to the astonishing collection of Canadiana that I had been privileged to view. Woven among the tales that Ruth had shared with me during our recent two-hour meeting had been recurring expressions of her frustration at not knowing what to do with her amazing treasures.

"My children are busy with their own lives and don't really seem to have too much interest in any of these things at the moment," Ruth had lamented. "And I just don't seem to know where to start to do anything myself. There's just so much of it here."

While I have been a lifelong student and lover of Canadian history, and have had the good fortune to have been able to document some rather obscure stories about this incredible country, my early thoughts concerning Ruth's collection were not with regard to presumptuously suggesting a book. Rather, it seemed that a national gem was in jeopardy – a jewel that deserved to be put on view for all to see. Something had to be done!

Yet another week passed. At the conclusion of a luncheon meeting with my Toronto-based publisher, concerning the possible reprint of an earlier book, I cautiously slid some of the photographs that Ruth had

kindly loaned to me across the table and awaited his reaction. Long moments passed.

"When do we start the book?" he said excitedly. That was all I needed to hear.

Apart from a passion for the study of history, an almost five-decade love of photography – set in motion when Prime Minister John Diefenbaker graciously posed for me when I was eleven years old – and, with more than thirty canoe trips into the Canadian wilderness behind me, the notion to consider doing a book seemed logical.

Returning to Ruth's home once each week for the next two months exposed me to further "mountains" of photographs and family memorabilia that invariably moved me to jaw-dropping reactions. I could not help but marvel at the care and diligence that must have been devoted to the preservation of such items, many of them hearkening back to the 19th century. But Ruth (Rushbrook) Beard was born into a long line of people who – as I would learn – were consummate students, documenters and collectors of human history, and, despite her ongoing health concerns, is a woman in possession and control of an extremely perceptive mind.

The files of our memory banks are only as adequate as the pictures and the printed stories and the life experiences we have consciously or unconsciously committed to them. Ruth could tell me only what she had been told. She had not yet been born nor been present when the majority of the family artifacts were collected or created. But she came from an era where sitting with father and mother, with uncle and aunt, and turning the pages of the dusty, leather-bound photo albums, and listening to the tales told by the first-hand actors who had appeared on those photographic stages, provided the fodder that would feed her quest for knowledge throughout the remainder of her life.[2]

"My family has always had a keen interest in history," Ruth told me during one of our early meetings. The reality and depth of that interest, however, could hardly be more understated by the humbleness of such a disclosure. The lines of descent extending back from Ruth (Rushbrook) Beard through her father and her paternal grandparents reveals far more than mere passing "interest." The Rushbrook clan have a clear genealogical trail leading back to the last quarter of the fifteenth century.

The book, *Rushbrook Parish Registers, 1567–1850,* a rather dry, less-than-stimulating record of Rushbrook kinsfolk, reveals one continuous and significant notion, however, that sheds light upon the attitude and thinking of several of the characters who will be considered shortly. The resulting behaviour provides the compelling – perhaps almost obsessive – inclination to document the history of their clan. Beginning with one John Rushbrook's death in 1496 in Suffolk, England, and meandering through some nine or ten generations that bring us to the arrival in Canada of George Rushbrook in 1859, the importance of preserving the family record was so ingrained as to have become a genetic propensity. The "documentation of the clan," which began with quill and quire in 1496, would evolve some 400 years later in the 1890s. It was then that George's son, Ernie, began to preserve the household records with silver-smeared, glass plates that captured images in a camera.[3] That George Rushbrook's wife, Eliza, contributed in full measure to the compulsion that Ernie and his eleven siblings inherited, deserves at least one sentence on this page also. Eliza (Gooderham Field) Rushbrook could trace her clan back to 9th century Danes, and could boast and toast the fact that one of her family members had established the famed Gooderham and Worts Distillery in Toronto in 1832.[4]

The Family Rushbrook was extraordinary, indeed, and yet not dissimilar from countless Canadian families who have come and gone during the past three or more centuries of our official (and unofficial) existence as a nation. The fact that George and Eliza Rushbrook had spawned twelve children, all of whom survived to adulthood in the 19th century was something of a rarity. While legions of infants and children succumbed to diphtheria, smallpox, scarlet fever or pneumonia, the Rushbrook brood, for the most part, thrived and enjoyed relatively good health. They were reared in a home that experienced an above average family income, and were blessed with the desire and opportunities to obtain good education.

Many tales of great interest and diversity could be related concerning most of the Rushbrook tribe, but it is the expeditions and adventures of only a few individuals, and their inherited proclivity to document the history of their travels, that will be the primary focus of what follows. A quartet of inimitable explorers, naturalists and

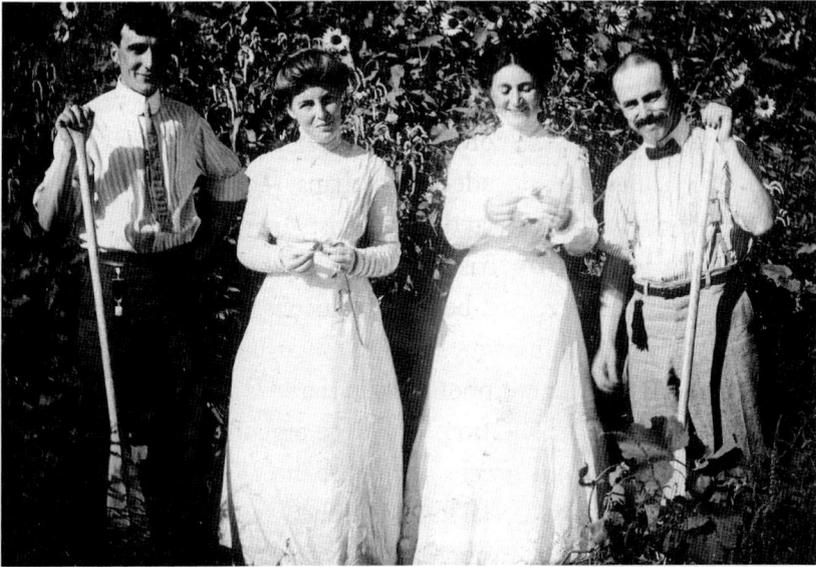

Left to right: Ernie Rushbrook, Ida Rushbrook, Bertha (Rushbrook) Sherman, Frank Sherman, Oklahoma City, 1908. Note the watch fobs sported by Ernie and Frank. These utilitarian items attached to their pocket watches were to become almost a "signature fashion statement" for the two men. As numerous photographs throughout the rest of this book will show, Ernie and Frank adorned their time pieces with various styles of cloth or leather fobs, often trimmed with tassels, trinkets or beads. Ida and Bertha appear to be fabricating daisy "chains."

photographers, however, is made complete with the entrance of Frank Sherman.

To suggest that Frank Sherman provided "comic relief" to the somewhat more assiduous-minded Rushbrook trio becomes apparent as one considers the content, composition and demeanor that he brings into many of the photographic images captured by the group. And while many early twentieth-century photographers – both professional and amateur – remained loyal to the stereotypical seriousness of posed subjects that had been the norm throughout most of the Daguerre-Victorian era, our four heroes broke free from that mould. Often, they presented facial expressions that allow the viewer insight into their humanness.

Ernie Rushbrook's daughter, Ruth, had bemoaned that she "didn't know where to start" when it came to organizing her father's

photographic collections due to the sheer volume of materials at hand. This was a feeling I soon began to share concerning the task of sorting, bringing to order, identifying and cataloguing the multiple collections and topics that were set before me as the early weeks of discovery continued to pass. It seemed prudent to perhaps begin by isolating a single theme. And while there existed – and exists – information and graphics that could serve as the basis for six or eight books, I kept coming back to the scenes that had been introduced to me first: the photographs of the French River.[5]

The greater part of the photographs that appear in this book have been electronically scanned from eighty- to one-hundred-year-old postcards: postcards that have been "victimized" by the fact that they were handled by the Canadian postal services of their day and also by the many fingers of adoring family members who have flipped through the images countless times. Some of the photographs have been reproduced from poor quality glass-negative plates. That said, the contrast and shading that we have come to expect from modern photographic methods may be less than pristine in the images that follow. It is hoped that the subject matter – the magnificent French River and the images from this historical period – will compensate for any apparent lack of clarity.

The French River is a Mecca for canoe aficionados and history buffs alike. While certainly a short and singularly less challenging river than the Miramichi, the Ottawa, the Red, the Fraser, the Skeena, the Mackenzie or the mighty Nahanni, the French River, nevertheless, holds an interesting pedigree. For a considerable number of years it occupied perhaps one of the most significant roles in the history of navigable waterways in Canada. Ernie, Ida, Bertha and Frank, by means of the images they captured, open a door to our knowledge of the history of the French River, much of which is previously unseen.

PART ONE

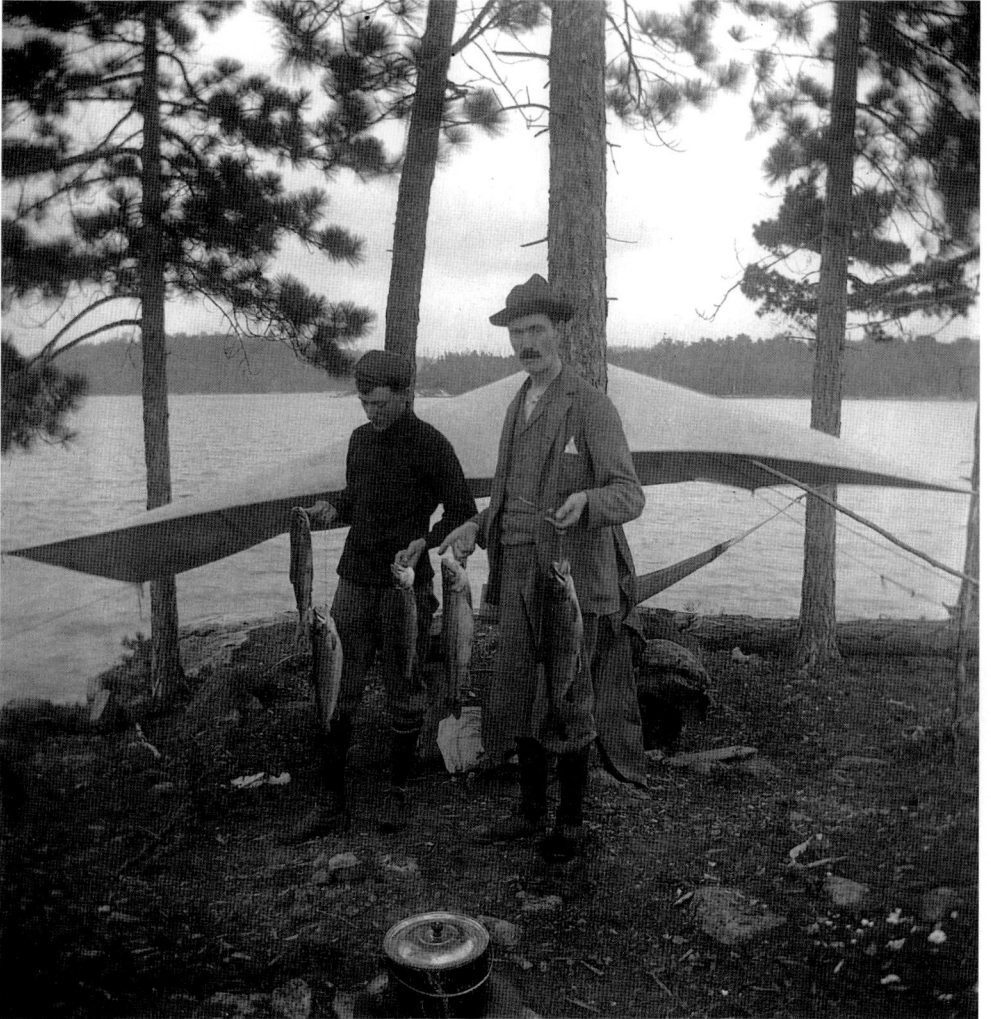

Ernie Rushbrook (left) and his brother, George, camped in the Muskokas, c.1894.
Shown here with a fine catch of trout for supper, they kept a very simple camp.
As seen in the background, a tarpaulin and hammocks served as their shelter.

Developing the Craft

The whole secret of the study of nature lies in learning how to use one's eyes.
 – George Sand, *Nouvelles Lettres d'un Voyageur*, 1869

D evoted scholars may spend decades, nay lifetimes, striving to analyze and understand the influences that may have contributed to the mind sets and the talents that have flowed from the great artists of the past. Few works of art have experienced the scrutiny that has been received by Leonardo da Vinci's *Mona Lisa*. And while such examinations began 500 years ago when that famous work was completed in 1507, da Vinci and his multitudinous talents continue to receive the attention of the modern scholar and the nonprofessional alike as each searches for meaning in the artist's authentic works or in the fictional fancies of mystic "codes" recently attributed to him.

The influences that were behind Ernie and Ida Rushbrook and Frank and Bertha Sherman as these four "Tom Thomson's" painted images on the canvasses of their cameras in the wilderness studios of northern Ontario are *not* encoded.[1] Rather, a relatively comprehensive photographic and documental record provides a measure of insight into how the skills of these photographers were honed and how their early training equipped them to capture a remarkable catalogue of images along the French River.

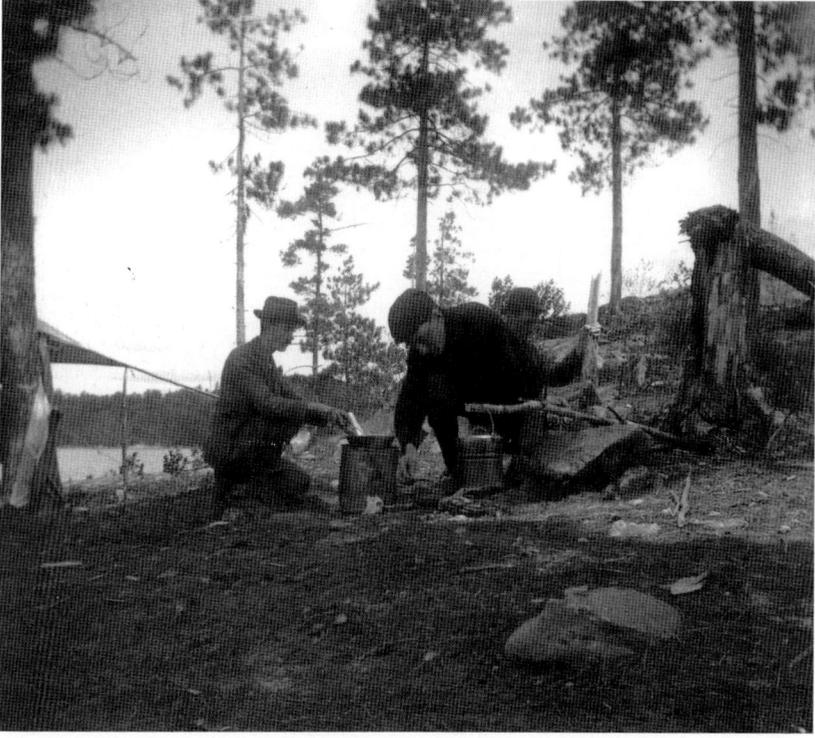

George Rushbrook (left), Ernie tending the camp fire, and a third person
(unknown) in the background. The skills Ernie was learning would be passed on
to his two sisters, Ida and Bertha, and his brother-in-law Frank, in years to come
as they set up countless camps along the French River.

Ernie Rushbrook would seem to have been the first of the foursome
to have fallen in love with the then new "science" of photography.[2] His
first-known photographs were shot in 1894 at age 16. While canoe trip-
ping with some of his older brothers and their friends, young Ernie not
only had the opportunity to experiment with his new hobby (he had
just acquired a photographic view camera equipped with his own home-
made timer and shutter release) but he also lent himself as an apt pupil
in the hands of these more experienced woodsmen. Being tutored in
the "arts" of canoeing, fishing, camping and how to cook a meal in the
bush, young Ernie was well on his way to developing skills that would
benefit him for decades to come. Of his three brothers, however, Walter
emerged as the one who was much more than brother, teacher and
friend to his ten-years-younger sibling. He was Ernie's first mentor.

ER-A.117

Numerous photographs and artifacts from Walter's adventures in northern British Columbia eventually fell into Ernie's possession. Whether this shot, c.1907, was taken by Walter or someone else, is uncertain. This twelve-metre-long "Great Canoe" coming ashore near the lower end of the Skeena River, was no doubt hewn from western red cedar.³

 To say that Walter Rushbrook had a passion for living his life out-of-doors would be a rank understatement. During his formative years in the late 1870s and early '80s, one of his Sunday School teachers, an erstwhile captain on a Great Lakes ship, had filled his head with tales of open water and the wind in his face. Signing on as a deckhand at the age of twenty-one, Walter subsequently obtained status not only as "first mate" but gained his pilot papers just four short years later in 1893. As his life progressed, however, Walter turned to a vocation that would become the *greater* preoccupation for the balance of his days – the Christian ministry. Receiving his clerical ordination into the Anglican Church in 1901, he served parishes throughout rural Ontario, until accepting a post to the community of Port Essington on British Columbia's northwest coast in September 1905. Taking the gospel up and down the Pacific shoreline and inland as far up the length of the

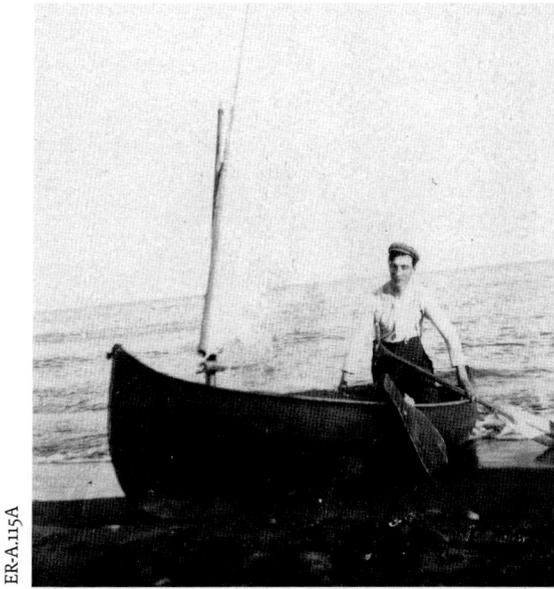

ER-A.115A

Ernie continued to perfect his canoe and watercraft skills as he entered his young adulthood. A regular pastime he favoured was a trip to Toronto's Kew Beach where he could rent canoes or small sailboats and depart solo into the often challenging waters of Lake Ontario. Twenty-two years of age when this photo was taken in the summer of 1900, Ernie was no doubt well on his way to discovering the intricacies of sail and rudder, skills he would occasionally employ with the rental boats that he and Frank periodically used in their trips from the mouth of the French River out to the Bustard Islands in Georgian Bay. Ernie was also fond of Kew Beach in winter. He was known to have frequently raced ice boats along the frozen shoreline of the lake.

mighty Skeena River as watercraft of the day would allow, Walter developed a reputation of renown over the course of several decades. Toward the conclusion of his time in the province, he was honoured by the Metlakatla people of the Tsimshian First Nation when they conferred upon him the title *Shemoigat ada gworl ba ahm aksh,* "Chief Always Running Water."[4]

While Ernest Rushbrook was feeding intellectually and pragmatically from the hand of his brother, Walter, he was quietly nurturing the seeds of his own skills and interests that were about to give birth. Meanwhile, his sisters Ida and Bertha were growing into sophisticated young women with their own artistic notions becoming well embedded. And though there is little hard evidence to suggest that these girls or any of their other sisters may have demonstrated an interest in photography during the 1890s, those skills would become manifest throughout the early years of the coming "new" century, as Ida and Bertha threw

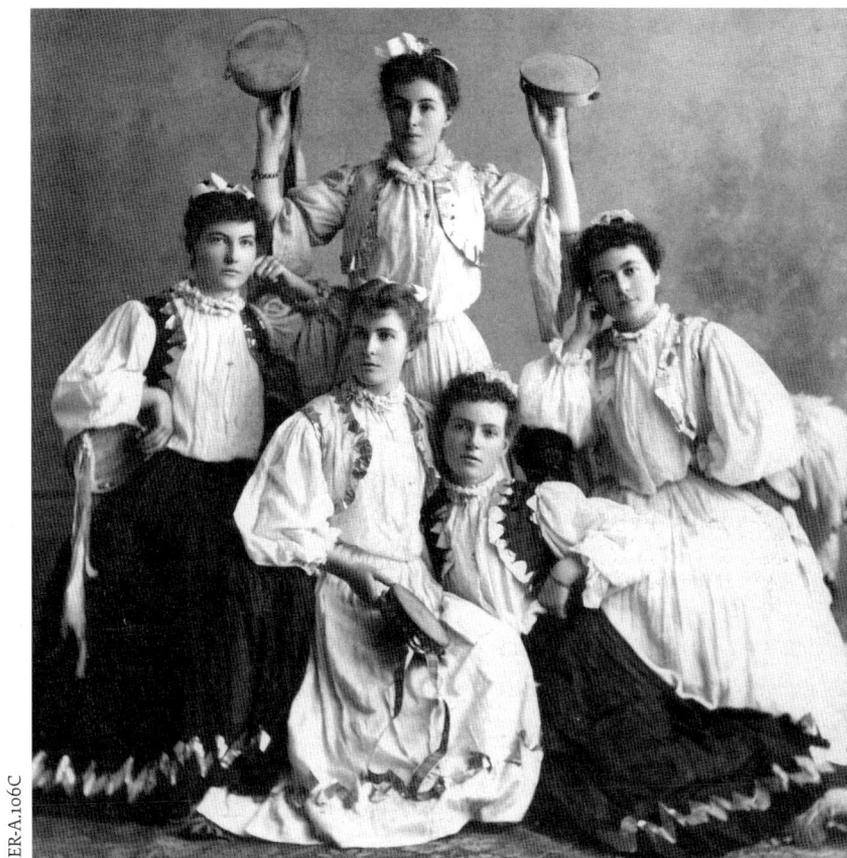

ER-A.106C

Five of the Rushbrook sisters in a theatrical review. Clockwise from the top: Ida, Bertha, Lucy, Marion, and Ethel (age 19), Toronto, 1897. As will be observed by a consideration of her facial features in many of the photographs that follow, Bertha (far right) frequently presented a "Mona Lisa" smile. While the photographer is unknown, it may possibly have been Ernest's work.

themselves into one wilderness adventure after another with Ernie and with Bertha's husband, Frank Sherman. What *did* present an artistic lure for the Rushbrook females in the last decade of the nineteenth century, however, was music, singing, dance and theatre. Many of the eight young Rushbrook ladies sang in Toronto church choirs, some as frequent soloists, while several were employed as organists. One telling photograph from 1897, features five of the girls in a theatrical review in which they are costumed with gypsy-like apparel and tambourines. And while some commercial photographers would not have been beyond

dressing five subjects in this way for a studio portrait, the design and intricacy of the wardrobe would seem to suggest something more than transitory. Regrettably, the exact location or theatre in which a presentation may have been performed was not recorded.

A further consideration of the practical value of these early interests embraced by Ida and Bertha will be revealed progressively as one views the French River photographs and contemplates their poise and demeanour amidst environments frequently hostile to urban niceties. With today's modern cameras and the ability to "click" a shutter at "blink-of-the-eye" speed – perhaps 1/2000th of a second or faster – the longer time exposures of the 1910s would have required significant patience. The fact, also, that a very large number of the photos were shot following a lengthy wait for a timing device to activate the shutter mechanism, reveals much about the endurance and forbearance of the subjects involved. This is especially notable when Frank and Bertha's infant son, Max, begins to join the annual expeditions. Through it all, as will be shown, it is a rarity that any of the surviving photographs reveal frowns, frustration or "aren't you finished yet?" expressions on the faces of Ida or Bertha as Ernie or Frank scrambled over rocks or hurriedly paddled a canoe in order to get "back in the shot." Quite to the contrary, a perpetual calmness, resignation and a remarkably patient deportment is projected by these two genteel young women.

For anyone strolling casually through today's antique shops or flea markets, the frequent sight of a cigar or shoebox overflowing with old family photographs is not uncommon. And it is no doubt lamentable, for both the former owner of the pictures or for the prospective antique hunter, that there is often little or no indication on the reverse side of the photograph that will act as an aid in the identification of the individual(s) or locale pictured. The Rushbrook and Sherman collections, while not perfect in methodology, do, however, very often have a date, a location, a clue that provides the history detective a reasonable chance of being able to identify the place, the time and the people pictured. Whether by means of a written note actually appearing on the reverse side of the photograph, or a companion document that may provide a manner of verification, dating specific items from the Rushbrook collections is generally very possible. In addition, many of the surviving

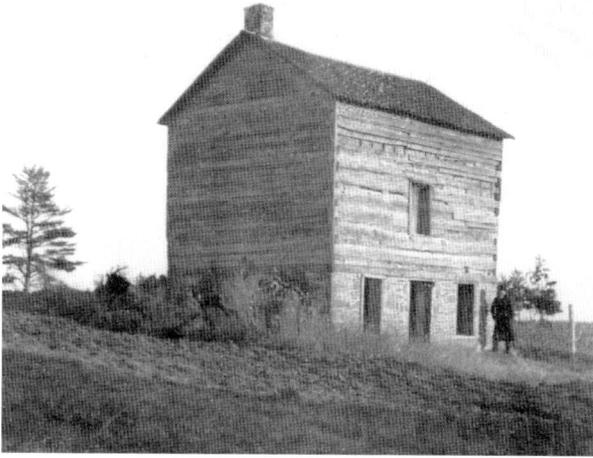

ER-A.124

A handwritten note on the back of this photograph says, "The first house Father slept in upon arriving in Canada, May 13, 1859." An additional notation indicates this photo was shot on November 28, 1901. The image was taken by Ernie. A very close magnification of the person standing beside the structure suggests it may have been his father, George. This would be a reasonable conclusion, since the senior Rushbrook would perhaps be the one person most interested in seeing this place, having been the man who had slept there forty-two years earlier. The building was located near Weston, Ontario. Being approximately 15-20 kilometres distance from the Rushbrook Toronto home, the return trip by horse and buggy would have been a significant jaunt in 1901.[5]

Bertha (left) and Ida, November 1906. A very close-knit family, all twelve of the Rushbrook children seemed to enjoy the companionship of their siblings. And while special relationships no doubt existed, there were few as close as these two sisters. Sporting new-style "stand-off" hats and mink (Bertha) and Persian lamb (Ida) hand muffs, the sisters present a much more serious demeanour than would generally be shown in the images of them captured in the coming years.

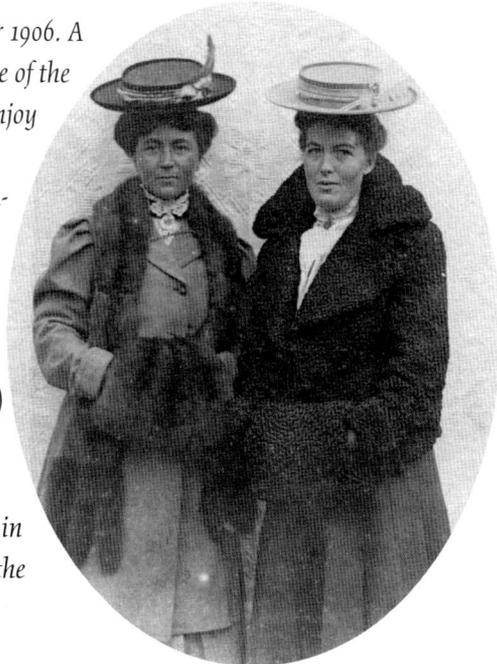

Photo taken by Ernie, ER-A.122A

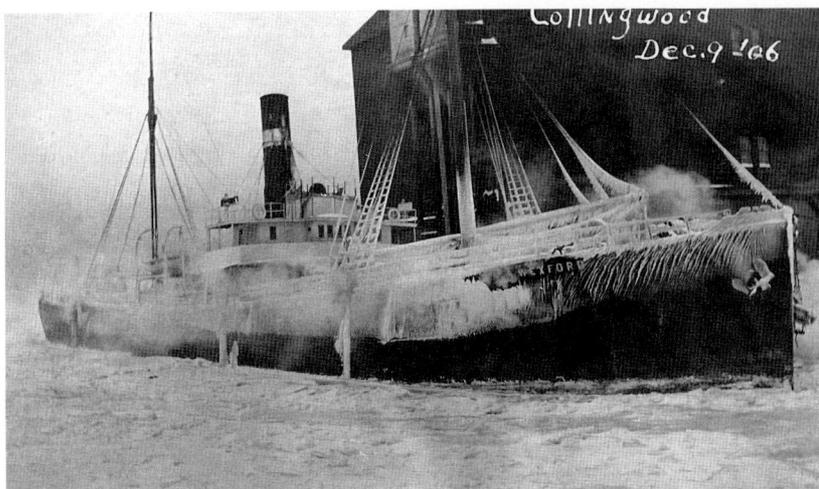

Collingwood
Dec.9 '06

ER-A.107A

With the passion Walter had for Great Lakes ships, it is possible that he may have been Ernie's companion for this trip to Collingwood, Ontario. This shot of the Wexford, *taken by Ernie on December 9, 1906, is one of five photographs taken of the vessel on that day. The* Wexford *foundered in Lake Huron during the Great Storm of 1913.*[6]

images, which are available only in postcard format, were mailed to family members and friends, and invariably bear the postal marks and a handwritten "signpost" providing day, month and year.[7]

One further pathfinder that was employed in the dating process is a close consideration of the clothing that was worn. Ernie and Frank, for example, often sported different hats on each trip to the French River. And while these two gentlemen invariably wore bow or long, slender ties with their shirts, the patterns and details of their attire often prove very useful. A comparison of dozens of photographs that may lack any other identifying marks can, by this means, often be dated with relative certainly. Similarly, observing the hats, dresses and sweaters of Ida and Bertha, may help with the process. However, this is not accomplished nearly in such a striking manner as is noted when analyzing the adornment of the male "peacocks" who accompanied them on their expeditions. And while, for the most part, it is the intention that many of the photographs in this book appear in chronological order, one of the more definitive methods of dating an unmarked image was to follow the current of their annual excursions by estimating the

age of Frank and Bertha's son, Max, who appears in virtually every canoe junket photographed between 1913 and 1927.

By 1901, Ernest Rushbrook was becoming a photographic artist with diverse interests. Architecture, ships, trains, portraiture, still-life shots and nature seemed to be the main genres that drew his eye. Many more examples of his work could be presented here, but would, no doubt, cloud the presentation and the importance of his "French River period." A selection of just three photographs, shown here, does provide a further appreciation for the disciplines and the interests that young Ernie was following during his early twenties.

FRANK SHERMAN COMES CALLING

Old George Rushbrook, while no doubt a proud father, would most certainly have had his hands full as the suitors began buzzing like persistent flies around his eight lovely daughters. As challenging as the process may have been, and with the hopes of seeing each of his "little girls" properly wed to an appropriate young man, he must have taken delight in the person of Francis Joseph Sherman when he appeared as a suitor. Known throughout his lifetime as "Frank," this prospective son-in-law, unfortunately, was only to have a very short-term relationship with George. The girls' father died just nine months before Frank and his youngest daughter, Bertha, were married. And while it is unknown just how lengthy the courtship may have been, it would appear that Frank and George had at least several months to get acquainted prior to the elder man's death.

Frank had been born in Toronto in 1875. His marriage to Bertha in June of 1908 would have found the groom at age 33, his bride being 28. Little information about Frank's early years has survived in the Rushbrook document collection, save to say that his father had been an itinerant Baptist pastor who had often been posted in the Essex and Kent County areas of southern Ontario and that, like Ernie, Frank had been enjoying the hobbies of photography and canoeing for some time.[8] Nothing more concerning the prenuptial life of Bertha's beau appears in print until the newspaper announcement concerning their marriage in which Frank is described as "the son of Rev. Edward D. Sherman, Harrow,

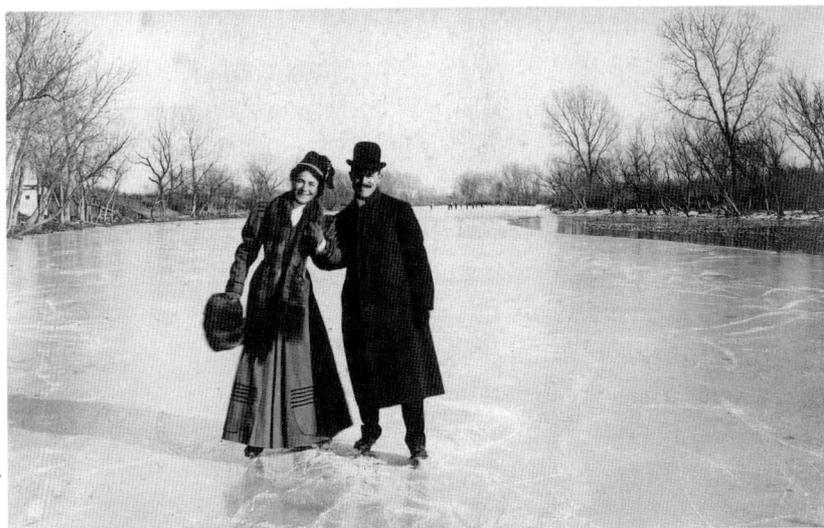

ER-A.131

"This is the first time I ever skated with hub," wrote Bertha on the back of this post-card. She and Frank would have been wed almost six months at the time. The photograph was taken by Ernie in late December 1908, on Grenadier Pond, High Park, Toronto, while Bertha and Frank were visiting from their home in Oklahoma City. Notice the open water at the right, and the group of "shinny" players behind.[9]

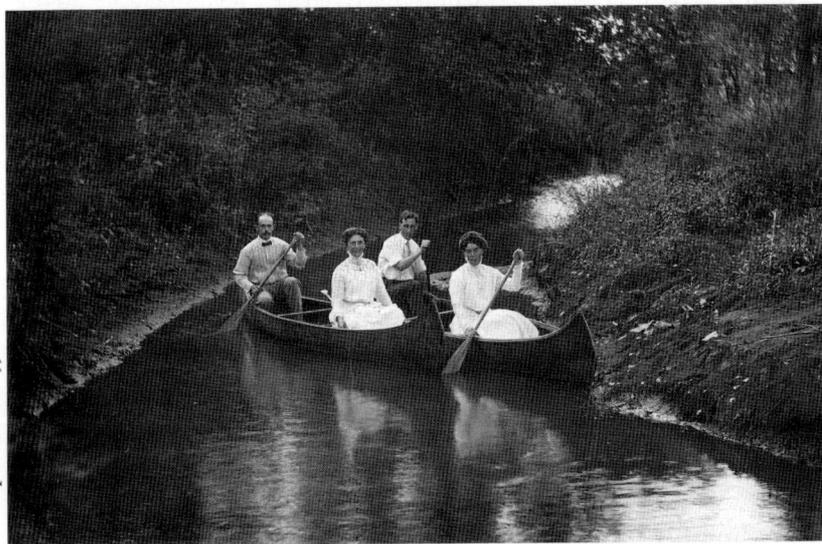

Timer photo, RB-CA.53A

Canoeing a quiet stream near Oklahoma City, fall 1908. Left to right: Frank, Bertha, Ernie, Ida.

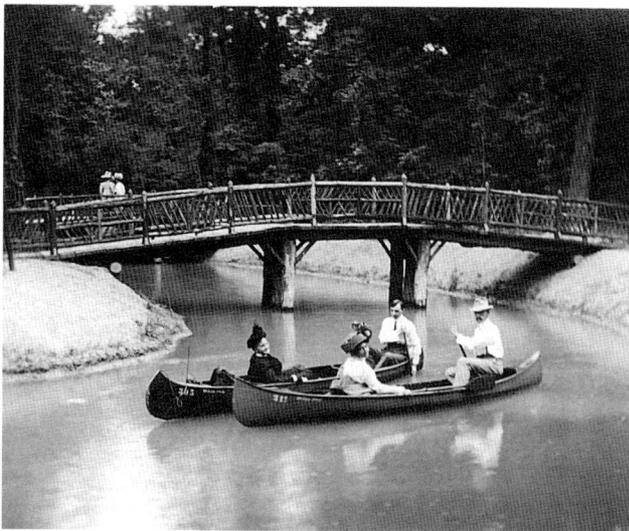

A Sunday after-
noon at Belle Isle
Park, Detroit,
1910. Left to
right: Eliza
Rushbrook,
Bertha, Ernie,
Frank.

Ida's photo, RB-MP.65A

Ontario," his mother apparently having died sometime before. No sib-
lings are mentioned as having attended the ceremony, and Frank is
noted only as "a resident of Oklahoma City, formerly of Toronto."

Not long after Frank and Bertha settled in Oklahoma following their
marriage, Ernie and Ida paid the newlyweds a visit, having travelled to the
"Sooner" state from Toronto by train.[10] Gracious hosts as they must have
been, Frank and Bertha arranged a canoe outing to refresh the weary pair.

Two years later, Frank and Bertha had moved to Detroit, and were
again visited by Ernie and Ida, along with their aging mother, Eliza. As
was the Shermans' custom, the refreshment "pill" for travel fatigue was
an afternoon of canoeing. Seemingly unrelated in time and place, these
two photographs are dovetailed together most interestingly because of
a small newspaper clipping that Frank had mailed to Ernie on August
30, 1913, shortly after their most recent, and the fourth, of their French
River expeditions.

Included among a few photographs and a letter, was a single panel
cartoon from an unknown, undated Detroit newspaper. Too fragile and
yellowed to be reproduced here, the animated sketch depicts a trav-
eller who seems to be expressing grief while reading a sign that indi-
cates he is yet a two-mile walk from the train station. Presumably, the
cartoon would have been intended to strike a humorous note with
Ernie, perhaps a reminiscence of a seemingly never-ending portage the

two men may have faced on their most recent canoe trip. Of greater interest – and no doubt unnoticed by Frank when he carefully scissored around the border of the cartoon – was a small story on the reverse side of the newspaper page. By very strange coincidence, it is this brief story that blends the two aforementioned photographs together. It offers a warning to young women who may venture to Belle Isle, a four-square-kilometre (982 acre) island and amusement park in the Detroit River. In part, the article reads as follows:

Country Girls Victims

In the public dance hall, a girl is in the crowd. She may dance close to her partner – too close for decency – but the presence of others is bound to put some check upon the performance. In a canoe on a stream on Belle Isle there is no such restraining influence. In a canoe a man may offer the girl whisky from a flask as she lies in his embrace and drifts through the Belle Isle woods.

"Many a young girl tells us of such stories because of this canoe evil," relates one police official. "Not a few are fresh from the small towns and the country.

Only a fortnight ago, I took charge of two pretty, little, rosy-cheeked girls, who had been in the city but one week," said the officer. They had met two fellows and were taken canoeing. The men kept them on the island until the bridge [back to the city] was drawn and they were compelled to remain [on the island] all night.

"I know they protested and were horrified at first, but when morning came, they accompanied the young men to breakfast in the city. After they had eaten, the men bought some beer, hired a rowboat, and were about to take the girls back to the island, when I got them," said the officer.

"The girls told me they were 18 and 20 years old, respectively, but they looked so young, I held them and

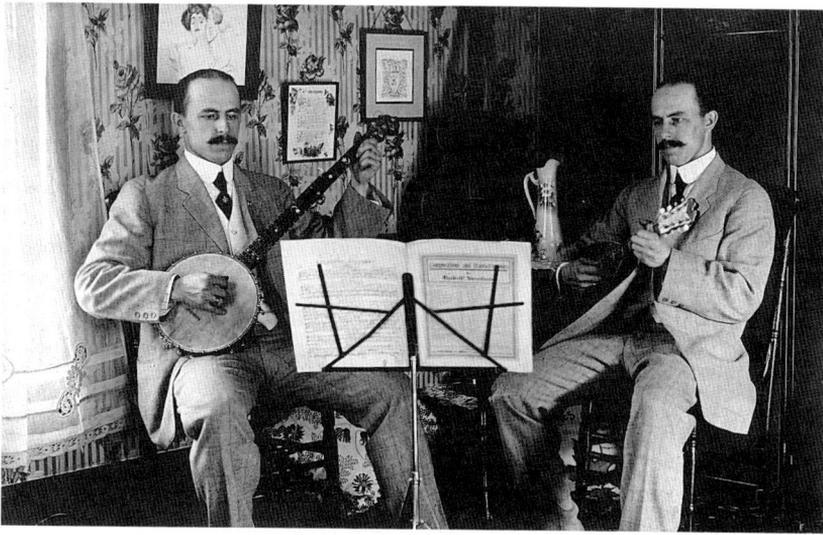

Timer photo by Frank, RB-PT.2

Frank Sherman, like his wife Bertha and her sister Ida, had both musical talent and a bent for theatrics. This darkroom-created blend of two photographs, some-times called "split-frame printing" is only one of half a dozen examples of his creative skill with this technique. Not only did he play the five-string banjo and mandolin, but also a guitar, seen in the background. Oklahoma City, 1909.

sent for their parents. The parents told me they were only 16 and 17 and that they had been 'very nice little girls' at home."

"The trouble with the canoe evil is that so few parents realize its danger," said the officer. "Young women need to beware."

A close magnification of the writing on the bow of each canoe in the Detroit-based photograph indicates rental numbers "305" and "311," but also the words "Belle Isle" painted on each craft. A point of further interest highlights the character of Eliza Rushbrook, who at age seventy-two not only had the spirit and courage to step into a canoe, but apparently gave no thought to the "canoe evil." No evidence of whisky flasks, beer or police constables in either photograph!

The photographic skills and artistic eye that Frank Sherman "brought to the table" as the adventurous quartet prepared to embark on a seventeen-year series of exploring and photographing the French

River was significant. From the darkroom in the cellar of his home in Oklahoma City, Frank had sharpened his chemical developing and printing abilities beyond what most amateurs of his day would hardly have imagined. Such knowledge gave him – as it generally has given most photographers who have "paid their dues" in the darkroom – a keener perception of just what the camera could do and how better to capture images that would remain timeless.

Communication with other humans, and the possibility of leaving behind a legacy, had for millenniums, been confined to handwritten documents and representations in sculpture or art. The 19th century changed all that. Revolutions were afoot. Revolutions began when Daguerre gave us photography, Morse the telegraph, Bell the telephone, Edison the phonograph, Marconi the radio, and with the stride of time, the advent of motion pictures, television, video cameras, cellular phones, the Internet, and e-mail. The power to communicate in our own choice of mediums continues apace. Frank Sherman, Ernie Rushbrook *et al* were enamoured with the powers given them by the cameras of their day. And while not alone in their passion for photography, they were very much a breed set apart from the norm amidst their Canadian contemporaries.

Little information about the exact photographic equipment used by our French River champions is available. It is known that both Ernie and Frank took large-view cameras and tripods on several of their early ventures, and while a few photographs feature their use of such equipment, there is generally a lack of clarity or close-up detail that would assist in identifying makes or models. Only a few dozen original glass plate negatives have survived in the Rushbrook collections, most of them being in the 107 x 107 mm square format with a few 102 x 127 mm rectangular plates also existing. We do know, however, that Ida and Bertha frequently used the "Folding Pocket Kodak Number 3-A, Model C" on most of their trips. Ernie's daughter, Ruth Beard, donated her father's Kodak to the Photographic Historical Society of Canada in 1983. A letter of thanks and a confirmation of the make and model of that camera was written to her at that time.[11]

With the majority of surviving photographs from the Rushbrook and Rushbrook-Sherman collections having been printed on 89 x 140 mm

postcard-stock photo paper, and many of them having been fingered by the Canadian postal service and scores of family members over the past 75 to 110 years, it is amazing that so many of the pictures are still in exceptional condition. Very few celluloid negatives from which the postcards were printed exist, and those that do have not survived well. Ernie and Frank were obviously fond of the postcard-size format as the medium upon which to record their photographic images.[12] Although not a common practice in their darkrooms, they did print some postcards on commercial stock that featured a preprinted border design that gave a framed or matted appearance around the image printed to some of the cards.

With colour photography yet many decades away, the prints that Ernie and Frank processed by the hundreds are the surviving black-and-white images that make up the greater part of the collection. But close to thirty of their prints, in formats ranging from postcard size to 30 x 50 cm size, were colourized using the most popular method of the day, water-soluble powdered paints. Applied carefully with an assortment of fine-hair brushes, a few of the more interesting examples of their work appear throughout this book. Due to the wide assortment of factors that could affect it – temperature, concentration of the mixed chemistry or simply the freshness of the batch – the print-developing process and the use of stop bath and fixer solutions could dramatically limit the archival life and contrast of printed photographs. And while most of the surviving black-and-white images have not "silvered out" or faded as has unfortunately happened with many photographic collections, most of Ernie and Frank's pictures have taken on a mellow, sepia-tone appearance and remain sharp and crisp in their contrast.

As important as it is, at this point, to give consideration of the actual French River photographs that were captured by the Rushbrook-Sherman foursome, one further essential story must be included if we are to gain a complete picture of the influences that contributed to the philosophy shared by Ernie and Frank throughout the rest of their lives.

PART TWO

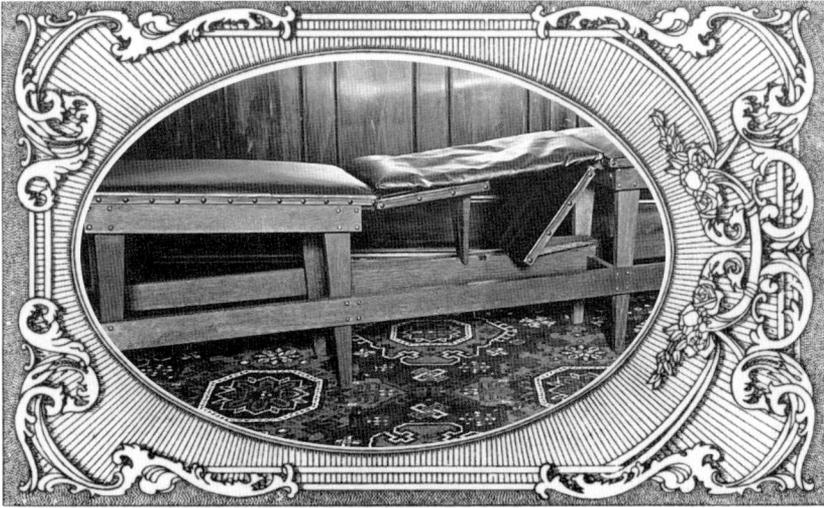

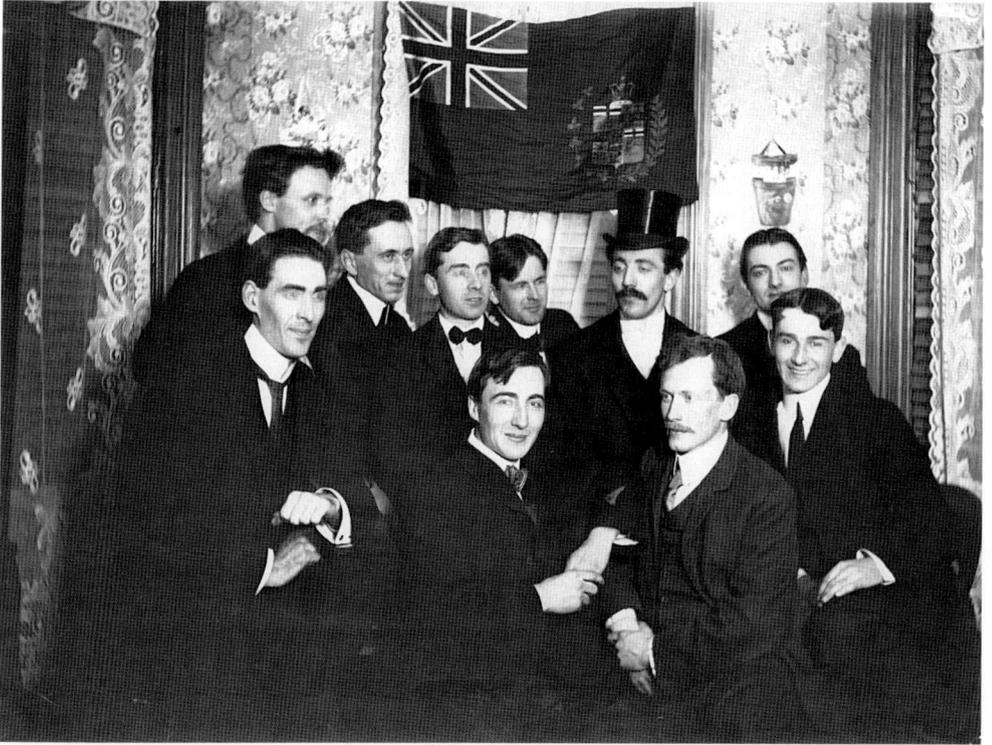

January 1902. Ernie Rushbrook (centre front) with a group of friends. Several other photos featuring some of the members of this group were taken by Ernie. Often showing humorous poses, the shots were indicative of the enjoyment he experienced from his photography. Since one of this 1902 series depicts Ernie and two friends studying from identical textbooks, it may be reasonable to conclude that this group of individuals were all students, no doubt apprenticing machinists, at the time. Ernie's position at the front of the group would be appropriate if he took the photo with his own camera and timer.

Laying on of Hands

Nature's own Nobleman, friendly and frank,
Is a man with his heart in his hand!
– Martin Farquhar Tupper, *Natures Nobleman*, 1844

E rnest Rushbrook's father, George, had been a tailor most of his
life. When the senior Rushbrook arrived in Canada in 1859, he
came armed with several letters of recommendation courteously
provided for him by his former employer in England.[1] Ernie did not
seem to have the patience, nor the interest, to work with needle and
thread. Instead, he decided that becoming a machinist might perhaps
be an interesting and rewarding career choice. And while his hobbies of
photography, canoeing and outdoor athletics were where he spent his
leisure moments, the "hands-on" lure of machining and engineering
metal components held the greater charm for this serious-minded
young man. Tinkering mechanically had always appealed to him. And
while an exact description of it does not exist, Ernie's homemade timer
for his cameras was thought to have been a clockwork and gear mech-
anism that depressed the shutter at the end of a preselected time
sequence, a method that he been employing since 1894 and one that
he would use frequently for many hundreds of French River photo-
graphs in coming years.[2]

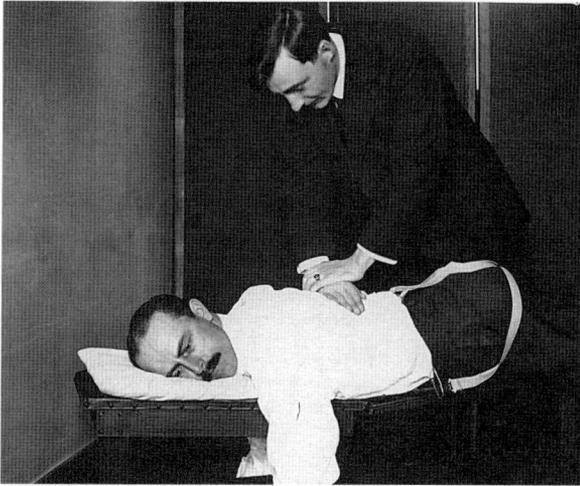

Ernie Rushbrook (standing) performs a chiropractic treatment to his brother-in-law, Frank Sherman, in their Detroit office, June 1910.

Timer photo, RB-CH.5A

For a period of time (c.1900–1907) Ernie Rushbrook had been gainfully employed as a machinist, first in Toronto, then in Schenectady, New York. Several of his own photographic postcards and numerous letters were mailed from his American residence to his parents and siblings in Toronto, indicative of the fact that his interest in photography was still alive. But some time during the winter of 1906–07, while he was back at home in Toronto, a bobsledding accident in High Park left Ernie with an injury that doctors of the time diagnosed as something that would leave him lame, if not somewhat paralyzed, for the rest of his life. And while the exact nature of the injury is unknown, it was apparently considered significant enough among underwriters of the period that Ernie was denied life insurance coverage for the rest of his days.

Disheartened as this active young man must have been, an introduction to his sister Bertha's suitor was to become a pivotal moment in his life. Frank Sherman was a kindly, compassionate individual who sympathized with the pain and dejection that seemed to be crowding in on Ernie's life. And while he was not a doctor, nor at that point had received any medical training, Frank had heard of a "new form of healing" that might possibly help his prospective brother-in-law get back on his feet. Chiropractic!

Chiropractic had appeared on the world stage in 1895, being introduced by its charismatic founder, Daniel David Palmer. Born on

March 7, 1845, in a log cabin in Pickering, Ontario, and later moving
with his family to a farm near Port Perry, young Palmer stood out as an
"odd child" among his seven siblings. As Dr. Joseph E. Maynard puts it
in his 1959 biography of Palmer:

> Summer was the season [Daniel] liked best. With the
> ground free of snow, he would spend any free time he
> had searching for the bones of animals that had died
> during the winter. While his brothers and sisters
> played with homemade toys, Daniel would take out his
> bone collection, tie them together in proper articula-
> tion with string, and try to figure out how animals
> walked and why the spine always seemed to be the
> main support of their bodies.

Maynard also relates that Daniel began to wonder, admiringly, about
his abilities to help people following an incident where he had laid his
hands on his mother's head and cured the woman of a series of violent
headaches.

As he grew to young manhood, Daniel David Palmer (or D. D. as he
would become known throughout the rest of his life) began looking for
greener pastures. Leaving Port Perry on foot in 1865, and arriving in
Detroit a month later, he hitched a ride to Chicago on a train filled with
soldiers returning from the American Civil War. Eventually settling in
Davenport, Iowa, and having dabbled in an assortment of jobs from
beekeeper to newspaper publisher to fishmonger, D. D. returned to his
childhood interests of studying bones, believing that he had the power
to cure people of their ills. Blending a mixture of "spiritualism and
alchemy," as some of Palmer's later critics would suggest, he had applied
himself to learning the fanciful new "art" of magnetic healing. After
observing the condition of a deaf janitor who worked in the building
where he had rented a small office, D. D. asked the man about his disabil-
ity. Learning that the man's deafness had developed suddenly seven-
teen years earlier when he had experienced a neck injury, Palmer applied
his hands to the janitor's neck and spine, pushing and manipulating in

short, sharp thrusts over a period of three days, And *voila!* – the man's hearing returned to normal. The first "chiropractic" adjustment had been made.3

To paint D.D. Palmer and his serendipitous discovery in a jaded manner, is certainly not the intention. Palmer's son, Barlett Joshua Palmer, and many other sincere practitioners and successors, took chiropractic to heights unimaginable whereby a "science" with a somewhat unfortunate early history ultimately evolved to a position of remarkable respectability. In 1995, when chiropractic celebrated its centennial, it was able to boast of having become "the world's second largest healing profession."4

With stories of amazing "healing" that no doubt were circulating during the first decade of the twentieth century, and with new discoveries and new technologies bursting on the scene with previously inconceivable suddenness, what had Frank heard or learned that moved him to suggest that chiropractic treatment might help his future brother-in-law, Ernie? Whatever it may have been, Ernie listened. He sought treatment from a new chiropractor in Detroit. And again, *voila!* Not only did his pain and partial paralysis disappear, but young Rushbrook – and his new friend, Frank – decided that this was a profession to consider.

After their marriage in June 1908, Frank and Bertha had moved to Oklahoma City, a place that had not one, not two, but three newly established schools offering instruction in chiropractic treatment.5 With his occasional visits to see his sister and brother-in-law, Ernie spent many hours with Frank discussing and analyzing the possible merits of entering the new profession. A prospectus was obtained from the Oklahoma Institute of Chiropractic and, following a six-month course, Ernie and Frank graduated together on December 24, 1909, becoming among the very first Canadians to assume the title "Doctor of Chiropractic."

Although Oklahoma City had been Frank and Bertha's home for two years, and despite the fact that Ernie and Frank had both graduated from one of that city's three chiropractic schools, they decided to move to Detroit in early 1910, There they opened their first practice in partnership. Choosing that locale was not a difficult decision for Frank

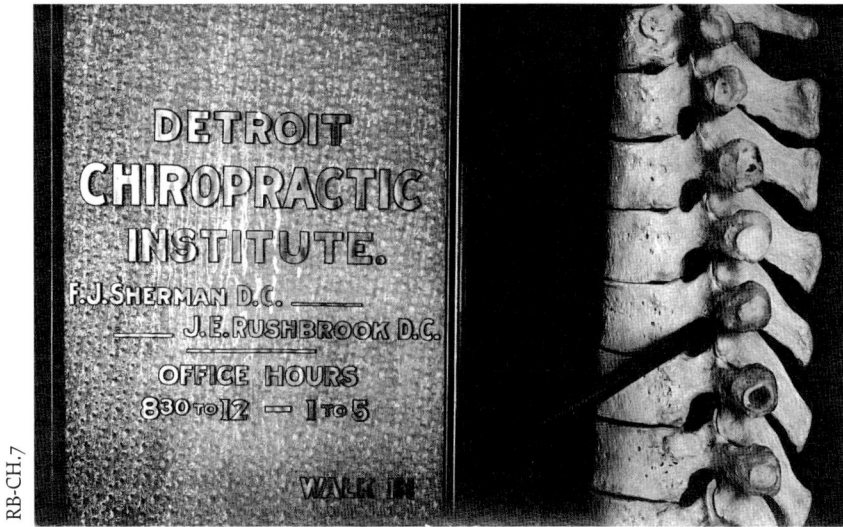

RB-CH.7

A postcard produced by Frank and Ernie in 1910 to advertise their practice, and no doubt mailed in abundance to new or prospective patients. The right side of the photo displays a human spinal column, a symbol the chiropractic profession continues to use down to the present. The office, known as the Detroit Chiropractic Institute, was located in the Park Building, 76-82 Washington Avenue. In the years that followed, as Frank maintained a practice in downtown Detroit, he was known to have frequently carried a handgun due to the growth of crime in the neighbourhood surrounding his office.

or Bertha. From the content of a half dozen of Bertha's letters and post-cards written from Oklahoma to her family back in Toronto, it is very obvious that the young wife had been desperately homesick so far away from her kin. And with much of Frank's youth having been spent just across the border in Essex County, Ontario, Detroit seemed like the perfect solution.

Perfection for some, however, may not be perfection for all. Only a few months after Frank and Ernie opened their office in Detroit, Ernie decided to move back to his old digs in Toronto. His diary of 1910 indicates that his first Toronto patient was treated on September twenty-eighth of that year. Ernie's fee was one dollar.

Frank and Bertha remained in Detroit for the rest of their lives. Their only son, Max, would later enter the chiropractic profession and also practice in that city, as did two of *his* sons several decades later.

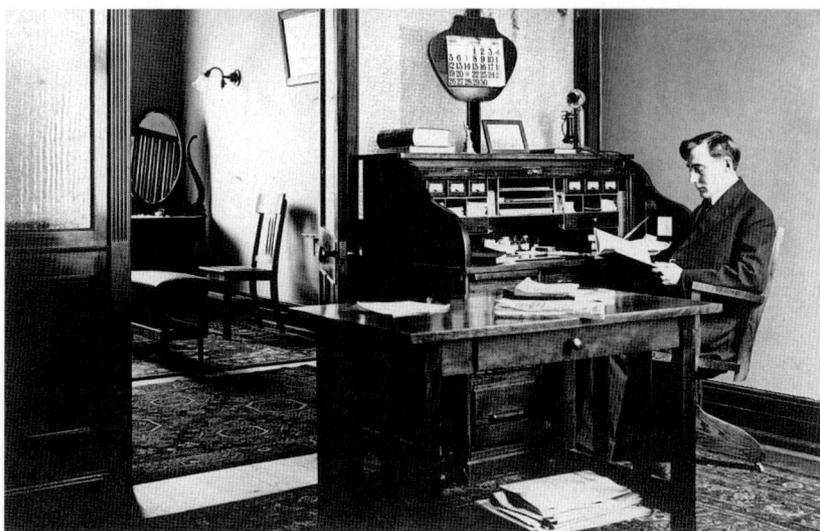

Frank's photo. RB-OS.40

Dr. Ernest Rushbrook in the office he shared with Dr. Frank Sherman in Detroit, June 1910. Ernie's diploma from the Oklahoma Chiropractic Institute is proudly displayed on the wall, and a peek at a treatment room is offered through the door at the left.

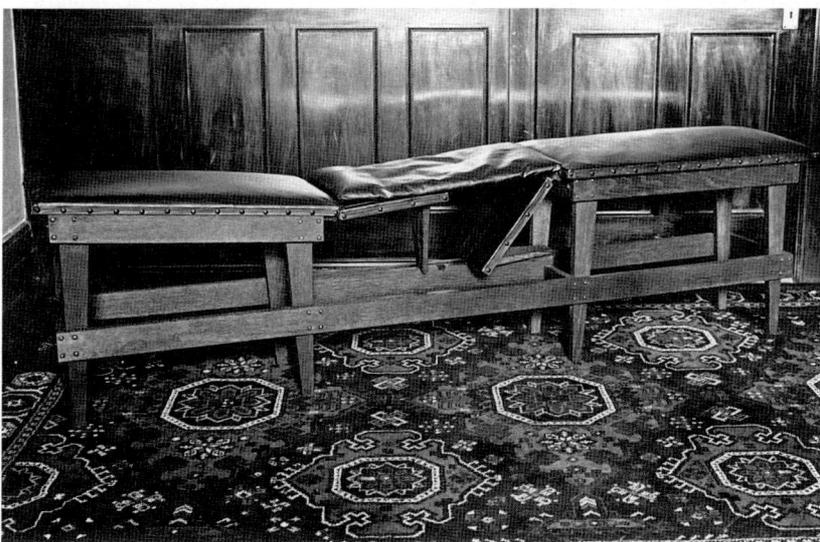

RB-CH.4

A chiropractic adjusting table made by Ernie Rushbrook in 1910. With a hinged, adjustable, thoracic or mid-section, the table could accommodate all manner of patients. Fabricated from oak with a padded, leather-upholstered top, the table no doubt reflected some innovations that Ernie, as a talented machinist, may have incorporated in the design.[6]

Happy with their Michigan location and lifestyle, Frank and Bertha frequently travelled by train from there, not only to visit family in Toronto, but often to rendezvous with Ernie and Ida at a convenient railway station in the French or Pickerel River region. From there they would commence their canoeing and photographic expeditions.

Little is known of the early days of Ernie and Frank as new, young chiropractors. But it became obvious in the years to come that both men had achieved relative success and were well respected in their chosen vocation. The choice to take up a career in a "healing profession" was a significant factor in the life philosophies and verve that each of the men would continue to demonstrate in their approach to photography, their love of nature and the fearless spirit they exhibited while venturing into the Ontario wilderness. Frank remained in practice in Detroit up to the time of his death at age eighty-six. Ernie practised in Toronto until his death at age eighty, when he was considered to be the oldest practicing chiropractor in Canada.

But far before the closing years of these interesting lives came a series of canoe expeditions and the compilation of a photographic record with few rivals in Canadian history.

PART THREE

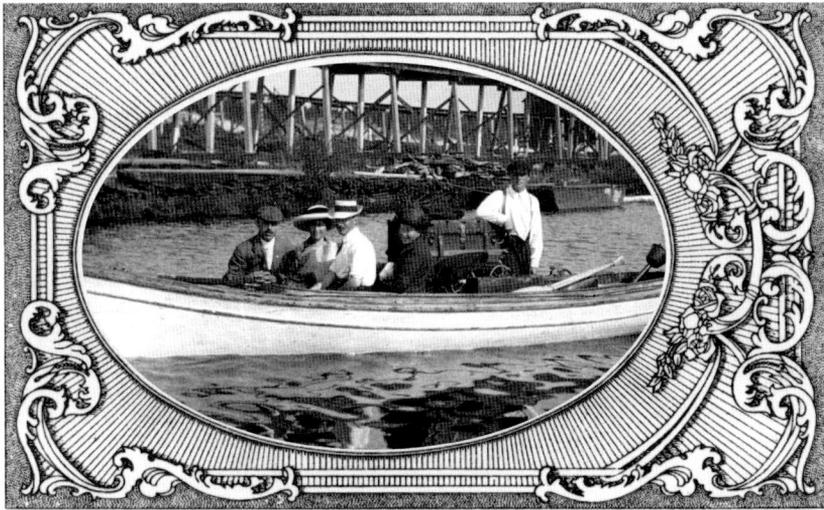

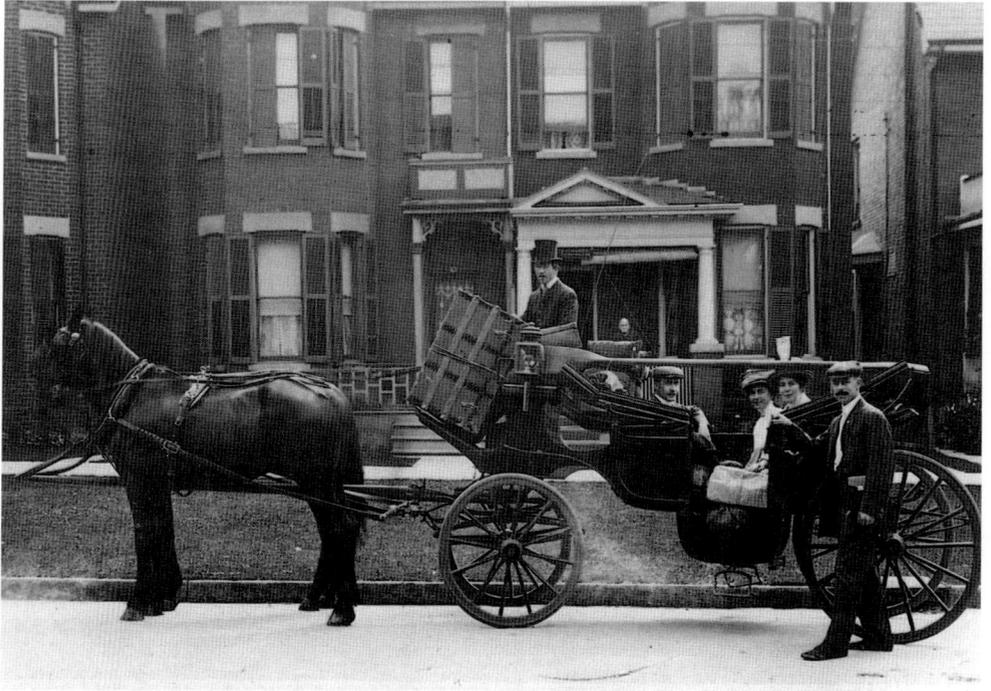

"Leaving for the station, 1912" were the words penned on the back of this photograph. The photograph was shot in mid-August in front of the Rushbrook home at 61 Lakeview Avenue, Toronto. Seated in the hired carriage are (left to right) Ernie, Bertha and Ida, with Frank standing at right, driver unknown. Containing most of their camp clothes and gear, the trunk propped up on the driver's platform was a feature that appeared in many of their French River trips. Ernie and Frank's eight-foot-long, double-ended paddles are also noted, spanning the gap between the folding-hood sections of the carriage. On Frank's shoulder is his Kodak Model 3-A camera in its case. In the background, Eliza Rushbrook looks on, no doubt with a mother's concern, as some of her "little ones" head off for a trip into the unknown wilds of northern Ontario. Hanging from the eave of the porch (just to the right of the driver's hat) is Ernie's professional shingle. It reads: "Dr. J.E. Rushbrook, Chiropractor."

Into the Wilderness, 1910–12

What sets a canoeing expedition apart is that it purifies you more rapidly and inescapably than any other. Travel a thousand miles by train and you are a brute; peddle five hundred on a bicycle and you remain basically a bourgeois; paddle a hundred in a canoe and you are already a child of nature.
– Pierre Elliott Trudeau

For several millenniums the aboriginal peoples of Canada have used rivers and lakes as their highways. In the region we now know as the French River, the earliest residents were the Palaeo Indians (sometimes called "Plano"). Occupying this area from as early as 2,000 B.C.E., the Palaeo tribes were supplanted by a group that anthropologists have called the Archaic Indians.[1] By about 200 B.C.E. the early Woodland Native people began dominating the area. By the time the Europeans arrived in the early seventeenth century, the Ojibwa had become the ascendent group – canoeing, trading, hunting and fishing along the French River corridor.[2]

By many standards the French River is a young waterway. About 8,000 B.C.E., the cold cloaks of glacial ice had receded from the Great Lakes basin. As the crevasse that would give birth to the river developed, water flow was in a west to east direction. But with rock masses and water sheds in a continual state of flux between 1,800 and 800 B.C.E., the land mass beneath Lake Nipissing rose, forming what is now the Chaudière Rapids. The French River then reversed and began to flow from east to west, spilling its chilled, silty waters into Georgian Bay.[3]

The French River is a relatively short water system, being only 105 kilometres long and dropping only about 19 metres between Lake Nipissing and Georgian Bay.[4] Across this short distance, however, rich moments in Canadian history have taken place.

The first white men to enter the river were Étienne Brûlé in 1610 and Samuel de Champlain in 1615. French Récollet missionaries (the "Grey Robes") arrived a few years later; then the Jesuits (the "Black Robes").[5] In a diary entry from 1616, Récollet Friar Joseph Le Caron provides a detail concerning his trip down the French River with Champlain. "With Indian guides we travelled up the Ottawa River, over portages to Lake Nipissing, crossing the lake, then down "La Rivière des Français" to Lake Attigouautan [now known as Georgian Bay] which [Champlain] named *La Mer Douce,* the Freshwater Sea."[6] And while the aboriginal peoples that proceeded them no doubt had assorted names for the river, from 1616 onward Champlain's designation "La Rivière des Français," or French River, would stick. During the 18th and 19th centuries, however, the Ojibwa name for the river was *Wemitigoozhi Ziibii.*[7] But the efforts of the Récollets and Jesuits to evangelize the "heathen" soon gave in to a wave of greedy commercialism that, in some senses, has continued to be an insult to the aboriginal peoples of the area down to the present, with land right claims and resource use issues topping the ongoing list of concerns. British explorers Simon Fraser, David Thompson, Alexander Mackenzie and others followed in the wake of those earlier canoes during the eighteenth century, providing maps and charts that would allow for the organization of a fur-trading export business, the likes of which had never been seen before, or since.[8]

The establishment of the Hudson's Bay Company in 1670 and the North West Company close to one hundred years later, saw the French River become little more than an "off-ramp," albeit a very important link, in the great watery navigation system that would eventually connect Quebec to Fort Chipewyan on Lake Athabaska in northern Saskatchewan/Alberta. By means of this 3,500-kilometre maze of canoe and portage routes, countless tons of furs and trade goods began to move.[9] Departing from the high side of the Lachine Rapids at Montreal, paddling up the St. Lawrence to the Ottawa River, on to the Mattawa River, across Lake Nipissing, down the French River to Georgian Bay,

though Lakes Huron and Superior to Fort William (now Thunder Bay), navigating through the hundreds of small lakes and rivers in northwestern Ontario, eventually into Lake Winnipeg and onward northwest to Lake Athabaska, the gruelling trip would not have been for the faint of heart. The fur trade was thriving, warming both the bodies and the pockets of European entrepreneurs.

Far more unwieldy than the Kevlar® or carbon-fibre canoes of our time, or even the leisurely-minded Peterborough or Rice Lake Company canoes that the Rushbrook-Sherman team would paddle down the French River in the early twentieth century, the massive *canot du maître* (master or Montreal canoe) and the somewhat smaller *canot du nord* (North canoe) were the workhorses of choice. They can be considered the equivalent of today's tractor-trailer trucks that rumble goods down the navigation routes of our asphalt and concrete highways.[10]

But the roles of commerce change as quickly as actors on a stage. The fur trade had been good to the French River communities. People in the aboriginal settlements along the river were reported to have gained benefits from employment as guides, *voyageurs* (canoemen in the service of one of the big fur companies) or as suppliers of food and provisions. With the beginning of the Napoleonic Wars (1805–15), however, trade from the Americas to Europe dwindled significantly. The fur trade went into decline. By 1821, the Hudson's Bay Company and their once powerful rival, the North West Company, had agreed to a merger (under the name of Hudson's Bay Company) in the hopes of keeping the fortunes flowing. But to no avail. The fur trade steadily declined throughout the rest of the nineteenth century.[11]

As it has frequently done throughout human history, war and disaster open opportunities for new means to reap riches. The end of the American Civil War in 1865 and the devastating Chicago fire of 1871,[12] coupled with a Canadian sense of optimism following Confederation in 1867, fuelled an unprecedented construction and building boom in Ontario. Lumber barons were born. The north shores of Lake Huron and Georgian Bay were "ripe for the picking." A seemingly inexhaustible supply of timber was not only available, but the proximity to American markets by means of Great Lakes shipping and log booming, was a positive impetus that allowed a new industry to reign as king.

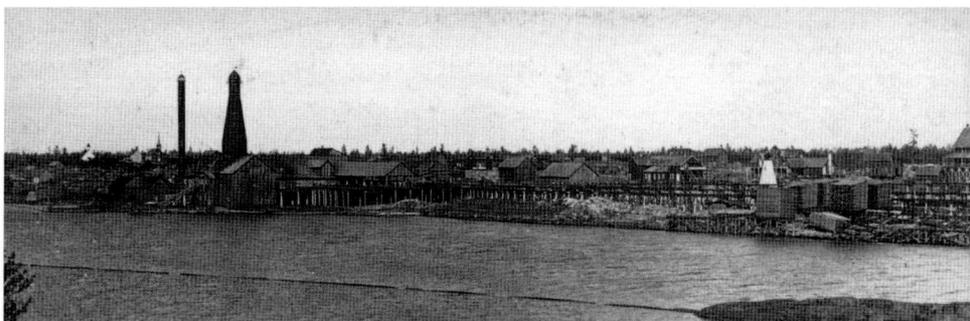

RB-CB.27

While panorama photography was nothing new in the early part of the 20th century, these two photographs taken by Frank and printed together on one post-card in his home darkroom, reveal much about the once-bustling lumber port of French River Village. At far left can be seen the two community churches and a school, then the boiler stack and sawdust incinerator at the Ontario Lumber Company mill. By following the main tramway out of the mill, we can see that it splits into at least three elevated sections. Piles of freshly-sawn lumber wait on the dock supports and cribs for loading onto the next incoming ships. The company boarding house (later used as a tourist hotel) is in the centre. Behind the lighthouse was the company store, library and recreation centre, while the offices of the firm were located in the building to the immediate left of the lighthouse. At lower left is a permanent string of logs, each fastened end to end with a short length of chain and two large spikes to form a corral that would keep scallywag logs that had escaped from the booms further upstream in MacDougal Bay from getting too far from the sawmill. This view was taken in 1911, looking east by northeast.

About thirty-five years before Ernie, Ida, Bertha and Frank were to begin their own adventures of discovery in the French River delta region, powerful forces were at work that would transform a bleak and barren rocky shore into a thriving commercial centre.

The idea of a transcontinental railway "to unite the country" had been a strong plank in the platform of Sir John A. MacDonald when he was elected as Canada's first prime minister in 1867. As the plans were formulated to that end, it became clear to many post-Confederation citizens that the enormous expenditure and tax burden required to make that "national dream" a reality, was about to get out of control. Adding to the financial anxiety prevalent at the time was the revelation, in 1873, that MacDonald had granted many contracts for rail construction to Sir

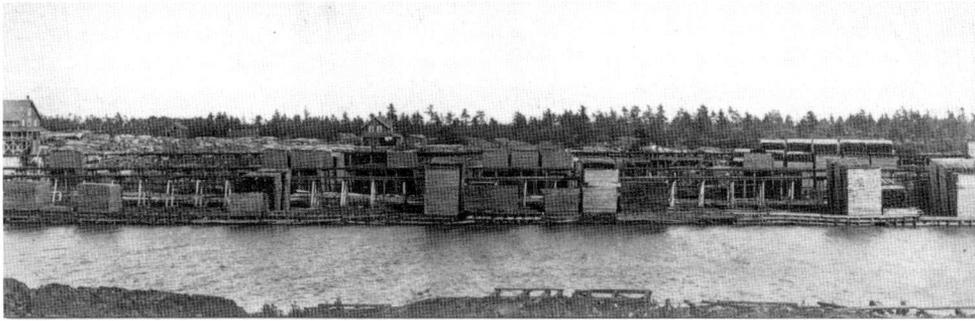

Hugh Allen, who, as it turned out, had been a very large financial sup-
porter of MacDonald's political campaigns. What became known as the
"Pacific Scandal" greatly angered the public as news of bribery, political
corruption and patronage broke. MacDonald resigned. Governor
General Lord Dufferin asked the leader of the opposition, Liberal
Alexander Mackenzie (not to be confused with the explorer by the same
name), to form a new government. An election was called, and in
January 1874, Mackenzie was given a governing mandate with an over-
whelming majority that completely routed the Conservative party.[13]

To pacify the populace, the Mackenzie administration outlined a
plan that would downsize the MacDonald scheme. The construction of
a steamship line and numerous ports would provide a navigation link
from Georgian Bay to Lake Superior, thus saving the horrendous costs of
building a rail line through the muskeg of northern Ontario. Among
other ideas floated by the fledgling Liberal government was the notion
that the French River could become part of a canal system that would
allow further inland shipping, which could eventually interconnect
Georgian Bay to Montreal. With the latter idea quickly finding little sup-
port, it was decided that building a rail terminus and steamer port at the
mouth of the French River would be a more cost-effective solution.[14]

Enter Provincial Land Surveyor, Thomas Bolger. Armed with tran-
sits, plummets, survey stakes and, most importantly, authority by com-
mission, Bolger fulfilled the mission to which he had been assigned. He
reported to his superiors on October 28, 1875, that the proposed com-
munity of "Coponaning" (apparently Bolger's name choice) at the
mouth of the French River, had been "surveyed, marked and was ready
for immediate construction" to take place. The field notes and town

plot plan that Bolger submitted illustrated nineteen streets and as
many as 157 building lots, 49 on the west side of the river channel and
108 on the east side. Among the comments made in the letter that he
submitted with his survey plan, Bolger lamented that "...the country
here is of the toughest possible description composed of granite rock
broken by rugged crags...The timber is all small and stunted, composed
mainly of pitch pine...On the entire [town plot] there is not ten acres
of arable land...I was not able to drive more than half a dozen posts into
the ground, but supported them with stones...The harbour is a very
good one, sheltered from all storms, but is a little difficult to access...If
the railway terminus is located here, there will be a demand for the lots
nearest the water..." With this less than glowing report now in the
hands of the commissioner of Crown Lands, the awkward stage was set
for the birth of a new community.[15]

Coincident with the Mackenzie government's rail terminus and
lake-port plans for the mouth of the French River, was the extension of
timber contracts in that area. In 1872, Thomas Foster, the minister of
Crown Lands of Ontario, spearheaded legislation that would allow the
opening of the northeastern margins of Georgian Bay to lumbering.
The granting of timber "rights" and licences to the men and companies
who were willing to hack wealth out of the wilderness encouraged a
sudden flurry of activity along the French.

One of the first white men to take up permanent residency in the
delta region was young Samuel Wabb. Having been born in Weston,
Ontario, in 1852 (the small community where George Rushbrook had
spent his first night in Canada in 1859), Wabb had a business sense that
would prove to be a good "fit" for the communities that would rise
around him. Having operated a mercantile business in Barrie, Ontario,
in the early 1870s while he was still in his twenty-first year, Samuel fore-
saw the fact that trading with the Native people in the region could
offer him a good living. After scouting a suitable location, he deter-
mined that an area just a few kilometres up the French River outlet
from Georgian Bay would be an ideal place to try his newly-conceived
business scheme. Throwing up a small trading post on a flat rock
plateau on the northeast side of MacDougal Bay, just below the Dulles
Rapids, he established what soon became known as Wabb Town.[16]

Samuel Wabb's little enterprise was actually located within the plan that was to be laid out as Coponaning, but that was of little account to him. Rapidly developing a trade relationship with local Natives, and having had the discipline to learn their Ojibwa language, Wabb's early stock-and-trade was to become the barter-exchanger of blueberries and beaver pelts, which he would ship to Toronto markets. Providing salt, flour, tea, tobacco, trapping supplies and other trade goods to the locals in return, Wabb quickly elevated his undertaking into a roaring business. But even greater opportunity was already knocking at the door.

Awareness of the volume of timber along the French and its feeder rivers, the Pickerel, the Wanapitei and the multitude of smaller tributaries, spread rapidly. Soon the rhythmic, tooth-gnashing sound of crosscut saws and the echo of the axe began to resound throughout the bountiful woodlands along the entire length of the French River. So plentiful was the resource, that even after almost two decades of plunder, logging contractor, John Armstrong, was quoted in the Parry Sound *North Star* newspaper as saying, "There is a full two million board feet of logs coming down the river this year." This amazing quantity of timber, by conservative estimates of the time, would have kept one large sawmill busy for five years, providing lumber that would have built a small city's worth of homes.[17]

About 1875 the Walkerton Lumber Company, employing some forty to fifty seasonal lumbermen, was established just south of Sam Wabb's trading post. Quickly noticing that the hastily constructed wooden shacks that these workers inhabited during their evening and nightly hours were grossly inadequate, Wabb built eight small homes and rented accommodation to the woodsmen for a nominal fee. The Walkerton company, while having the potential to have done more, cut relatively small sections of timber. For several years they boomed logs together and towed them by steamer tugs to mills in Georgian Bay and even across Lake Huron to Michigan, instead of milling lumber themselves. By 1883, however, a more ambitious effort began to take place when the Walkerton Lumber Company assets and timber licences were bought by a consortium of individuals, among whom were Herman Henry Cook and his wife Lydia, Edward MacDonald, Fred Hammit and John Melville Dollar. Establishing themselves as the Ontario Lumber

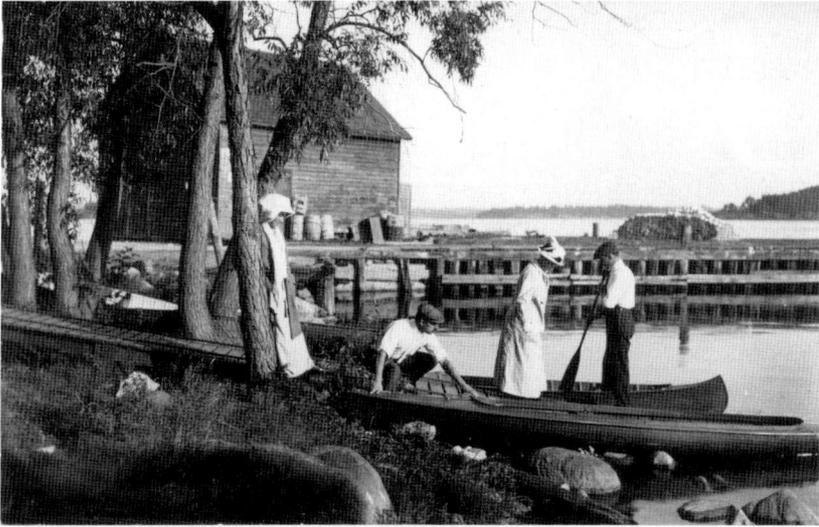

August 1910. This is perhaps one of the earliest French River photographs taken of the foursome who were about to embark on the first of many trips along the river together. The location is a dock at French River Village. Several different canoe styles are noted at the dock and in the background at the left, indicative of the variety of rental canoes available from village outfitters at the time. The long "duster" coats worn by Ida and Bertha, a style often sported by both men and women when travelling in early motor cars, gave way the following year to slightly less cumbersome attire. Left to right, Bertha, Frank, Ida, and Ernie.

Company, they registered the letters of patent incorporating the new company were registered in Toronto on May 9, 1883.[18]

Ignoring the government-commissioned Coponaning survey, Herman Cook's gang decided to construct a large mill for their newly formed company on what they deemed a slightly more suitable chunk of rock just south of the previously surveyed plan. Within just a few short years, three hotels, a boarding house, dozens of homes for workers, two stores, a post office, two churches, a library, a doctor's office, two schools, a jail, a lumber storage and dock system and a lighthouse had been built. The community of "French River Village" had come into existence. Continuing to experience growth as the lumber riches poured in, the village expanded to the north, spilling into the original Coponaning town plan. In less than a decade, the power and the influence of French River Village so dominated this

Tea - 2 lbs. $.70	Soups .50	Oranges and Bananas
Sodas, box .33	Eggs 2.13	.70
Cheese, 2 lbs. .40	Chicken .59	Chocolates .95
Beans .06	Salt .15	Rope .20
Steak 1.76	Sugar .75	Putty .05
Butter, 6 lbs. 1.92	Flour .50	Sage .10
Bacon, 9 lbs. 1.80	Rolled Oats .50	Biscuits .60
Lard .60	Rice (candies) .15	Photo Supplies
Carrots .25	Raisins .25	4 1/2 Film Packs 7.20
Plums .45	Milk .70	6 # 3-A Kodak Films
Whiskey 1.00	Cocoa .10	2.40
Chiclets .50	Nails .05	Devel. Chemicals .40
Candies .50	Soap .05	
Rifle cartridges 1.00	Baking Powder .15	Total Expenses
Nuts .30	Soda .05	$ 44.16
Jam 1.00	Matches .05	
Jelly .35	Bread .78	
Ginger 1.00	Candies (Fenton's)	Send 30 postcards to
Frying pan .50	.90	Udy's
Vegetables 2.40		Send 25 postcards to
		Bert

"Camp Expenses 1912" was the title Frank gave to this list of supplies. Originally type-written in three columns, Frank's meticulousness reveals an accountant's thinking. Surviving records indicate he generally took on the role of quartermaster, assisted by Ida, for most of the French River expeditions. Scribbled in pencil at the bottom of this list was a note: "Nov. 30/12, Ern and I squared all money matters."

location on the river channel that the names Coponaning and Wabb Town gradually disappeared.

Hopes that a rail terminus might eventually be built at the mouth of the French countined to build. However, Sir John A. MacDonald, who had been ousted from the prime minister's seat in 1873, regained power in 1878. With Sir John's renewed and revised plan for a transcontinental railway, which was actually realized in 1885, this expectation of a "short haul" rail link to French River Village began to fade. Not easily disheartened by the whims of political change, the dynamic Ontario

Lumber Company took a fresh look at the natural advantages that were already available to them – the French River, their proximity to Georgian Bay and hence access to the entire Great Lakes system. Effort was applied to lengthening and upgrading their docking facilities and several tug companies were established to assist ships in and out of the harbour that surveyor Tom Bolger ten years earlier had described as "a little difficult to access." The invitation to sailing ship and steamer alike was extended far and wide. By 1900 French River Village was booming. Ships arrived and departed several times a week carrying lumber to far-distant Canadian and U.S. ports. Population estimates ranged from 600 residents (in the winter seasons) to as many as 1,500 during the period of 1890 to 1910.[19]

Along with the frequent flow of cargo ships in and out of French River Village harbour, came passenger steamers from Collingwood and Owen Sound. The three hotels, which, for the most part, had originally housed mill workers and the men who frequently stumbled in "dog dirty and loaded for bear" from the scores of lumber camps that existed up and down the river system, could now cater to a more diversified clientele. The move toward tourism added to the colour, excitement and the economy of the village. As early as 1892, the Queen's Hotel – considered to be the best in town – took out an ad in Georgian Bay community newspapers. One of them, the Parry Sound *Colonial*, promoted the Queen's with an ad that read: "Tourists will find this a first-class hotel. Good fishing and shooting in close proximity. The wines, liquors and cigars are the best. Billiard Room and Barber Shop in connection."[20]

The Grand Trunk Railway (later to become part of the Canadian National Railway), while not running a rail line directly into French River Village, inadvertently contributed to the economy of the area with the billboard ads they placed in their Toronto station. The full-colour posters hung in virtually every "two-bit" junction station along their entire rail network. Their frequent newspaper ads that appeared during the early decades of the twentieth century, also contributed. Always conscious of opportunities to promote train travel, the company hired some of the finest illustrators and photographers of the day to highlight glorious Canadian landscapes and to romanticize the excitement of travelling to these exotic locales on their luxury-laden

RB-FE.62

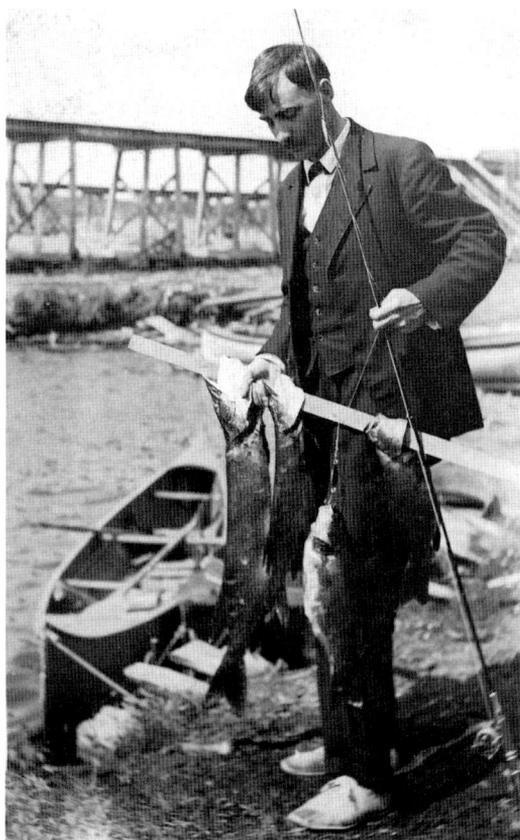

Circa 1910–11. In the narrow slip of water that existed naturally at French River Village, Ernie – striking a pose uncannily reminiscent of several surviving pictures of Tom Thomson during the same era – displays his afternoon catch. The two pike, and what appears to be two pickerel (walleye), would make a fine meal. Wearing a three-piece suit, Ernie Rushbrook does not appear to be concerned about his exposure to fish guts while the catch was being prepared for the skillet. Since an identical photo of Ida exists at the same location, with the same stringer of fish, it may be concluded that the photograph was her shot. The Ontario Lumber Company's elevated tramway is in the background.

passenger trains. Canadian Pacific Railway (CPR) had also been a strong developer of tourism with a similar style, and both companies eventually built impressive hotels and lodge facilities from coast to coast that further prompted train travel. One such ad campaign in 1896 that was of direct benefit to the French River area, encouraged travel by train to Owen Sound or Collingwood, at the south end of Georgian Bay. There, the traveller could board a steamer for an enjoyable ride – which included a fine meal – to the port of French River Village where canoes could be rented and supplies obtained. "Paddle up the historic French River, across scenic Lake Nipissing to the picturesque community of North Bay, then travel by rail south to Toronto," was the promotional cry. Literally thousands of adventurous Canadians and Americans

responded to such advertising, contributing to the birth of a tourism industry that has reaped benefits down to the present day.[21]

The ribbons of steel would not forget the French River Village area entirely, however. In 1908, Canadian Pacific Railway completed their line from Toronto to Sudbury, crossing the Pickerel and the French rivers just east of present-day Highway 69. A small passenger station was erected on the north side of the rail bridge that crossed the Pickerel. And the James Bay Railway Company – later acquired by Canadian National Railway (CNR) – hacked their way through the bush that same year with a rail line that likewise crossed the Pickerel and the French and passed through the community that is now known as Hartley Bay, just fourteen kilometres (by water travel) east of French River Village. Although the initial plan had been to lay track directly to the village, engineers and surveyors determined that the more easterly route would be less troublesome and more cost effective. Many materials to construct the CNR route were, nonetheless, shipped to French River Village and then transported by barge to the respective construction sites. Both the CP and CN rail lines opened wonderful opportunities for travellers coming north from Toronto.[22] Beginning in 1910, and continuing through to 1927, the Rushbrooks and Shermans used both the newly opened CPR and CNR river-crossing passenger stops as "jump off" points from which they would begin their camping, fishing and photography excursions.

French River Village seemed to have a lot going for it. Lumbering was a well-established industry and the foundation of their peaceful river community. The growing numbers of tourists coming into the area seemed to be providing just a little "gravy" to make things even better. But Canadian history has shown us repeatedly that one- or two-industry towns often awaken suddenly to the fragile nature of the economies that support them. Dark clouds that would soon envelop French River Village were gathering on the horizon.

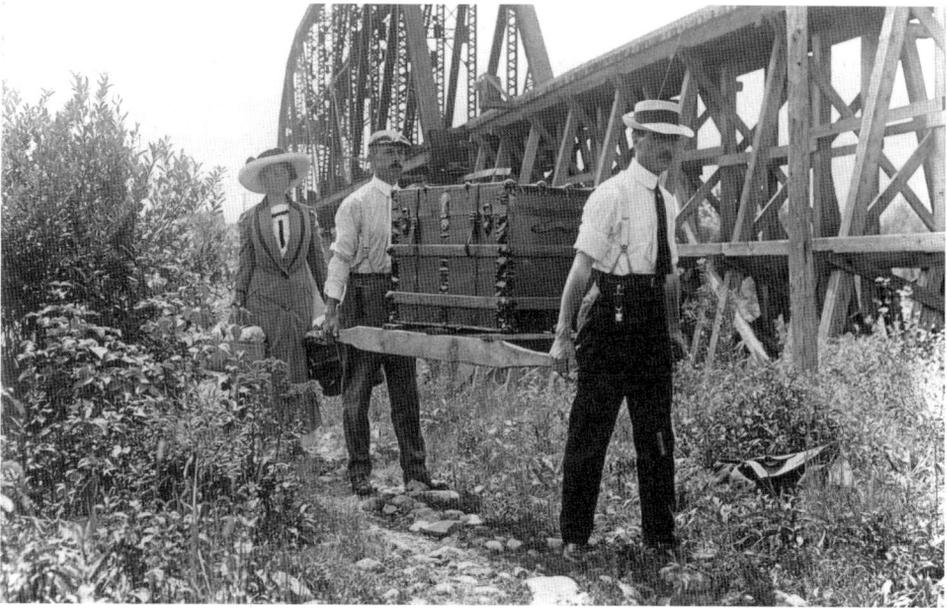

Ida's photograph. RB-TG.3

With several document clues available to indicate their travel plans for their
1911 trip, it is possible to determine the location of this photograph. The site here
is no doubt just below the railway bridge and trestle (CPR) at Pickerel River
Landing. A pathway leading from the station to the river dock finds (left to
right) Bertha, Frank and Ernie carrying their gear to a waiting motor launch
that would take them down the Pickerel to the French River and on to French
River Village. The wooden litter, upon which the trunk is being carried, was
possibly an aid provided by a local outfitter or the owner of the boat that was
about to transport them to their destination. Upon arriving at the village – as
it became their custom on many trips – they would change from their travel
clothes, remove their camp clothing, cameras and gear from the trunk, and then
store the trunk with Postmaster Dean Udy, or with one of the other resident
families that they befriended in the village during the course of their annual
expeditions into the area.

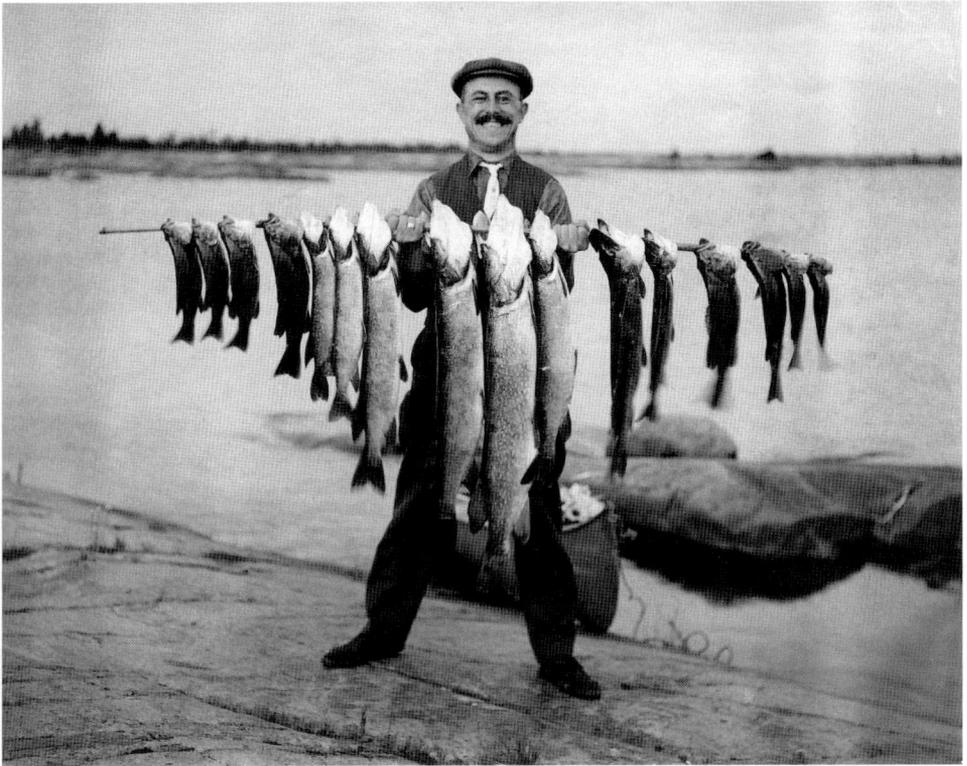

Ernie's photo. RB-OS.15

Beaming with delight, Frank proudly displays this fine mess of pike and pickerel during the 1911 junket. By many of today's standards, the numbers of fish regularly caught by our travellers far exceeded reasonable limits. And while there were quotas legally in place along the French and Pickerel rivers by 1912, this stringer of fish would not go to waste. After everyone had their fill for dinner, Ernie and Frank would clean, gut and fillet the remainder of the catch, pack the fish in rock salt, and early next morning canoe to either the CNR or CPR station closest to their camp. There, they would further package the fish in waxed burlap or a small wooden crate and ship them home to Mother Rushbrook, sent by express in the baggage car of the next southbound train. Since as little as three or four hours would have brought the pleasant-smelling package to her door, she could then go to work preserving the catch for further use. As was customary in the period, the fish may have been further salted, submerged in brine, dried, iced or canned in jars.

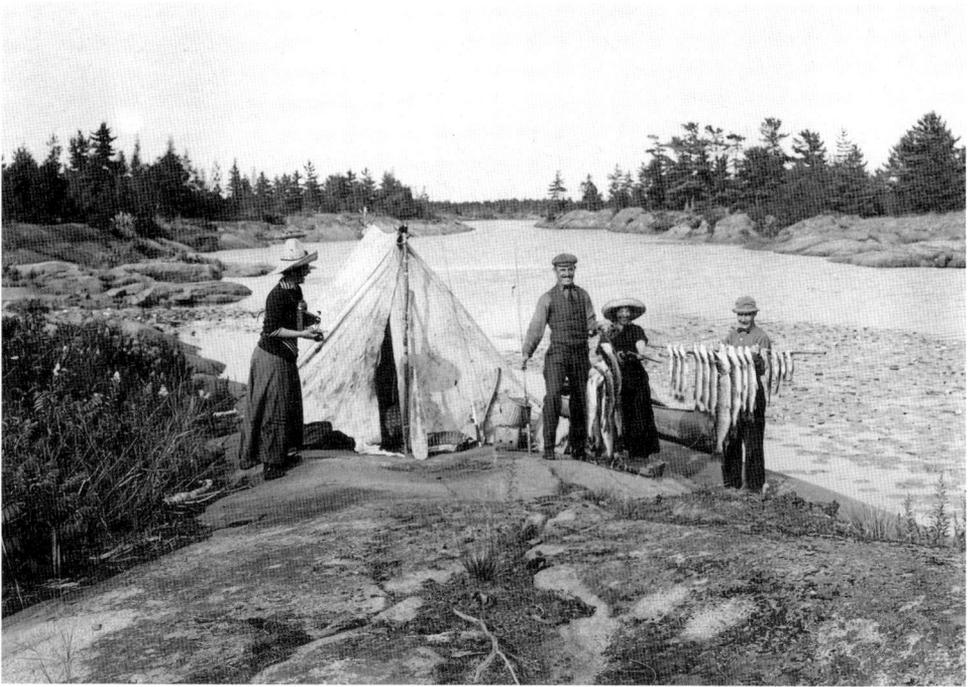

RB-OS.3

As impressive as the day's catch of fish may be, other details in this 1911 picture reveal significant facts concerning the methods often employed by these photographic adventurers. One of their view cameras, with timer, would have captured the image. But the greater interest is the fact that Bertha (at left) has been posed to show her as taking a picture of the group with her Kodak and Ida is pointing a gun at the fish held by Ernie. One can almost hear the laughter among these four friends as they put this scene together and then waited for the shutter to click.

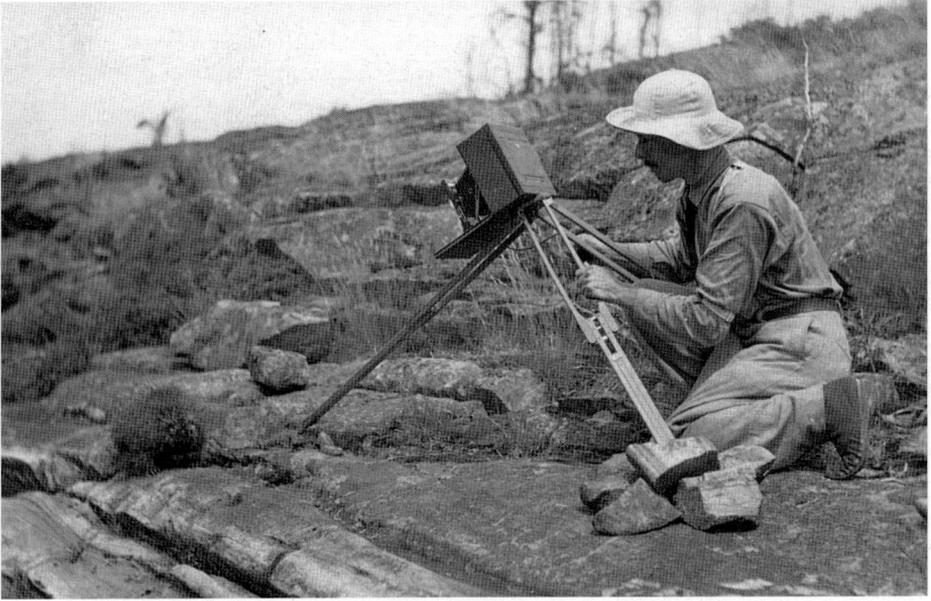

*This 1911 photograph is one of the few surviving images that features one of
the two-view cameras that Frank and Ernie took on their early French River
expeditions. Since there were simply hundreds of camera manufacturers in the
period 1890-1910, each offering various models, it has proven difficult to identify
the camera precisely. Magnification of the photo reveals that this camera was
relatively compact (folding into itself), that it had a sliding bellows focal mecha-
nism, and that the negative carrier appears to have been square (accommodating
the 107 x 107 mm glass-plate size as discussed in Part One). Frank's cooperative
subject, a porcupine, is considered to be one of Canada's best-known mammals.
In greater abundance one hundred years ago than it is now, from the photo-
graphs that have survived in the Rushbrook-Sherman Collection, it would appear
that a healthy and prolific population of the animal was to be found in the
French River area. A small detail, perhaps, but significant for the canoeist and
camper in modern times, is the fact that Frank is wearing a pair of rubberized
canvas shoes. The flexibility of this footwear (as can be seen in the picture) made
this an excellent choice for the activities in which they engaged.*

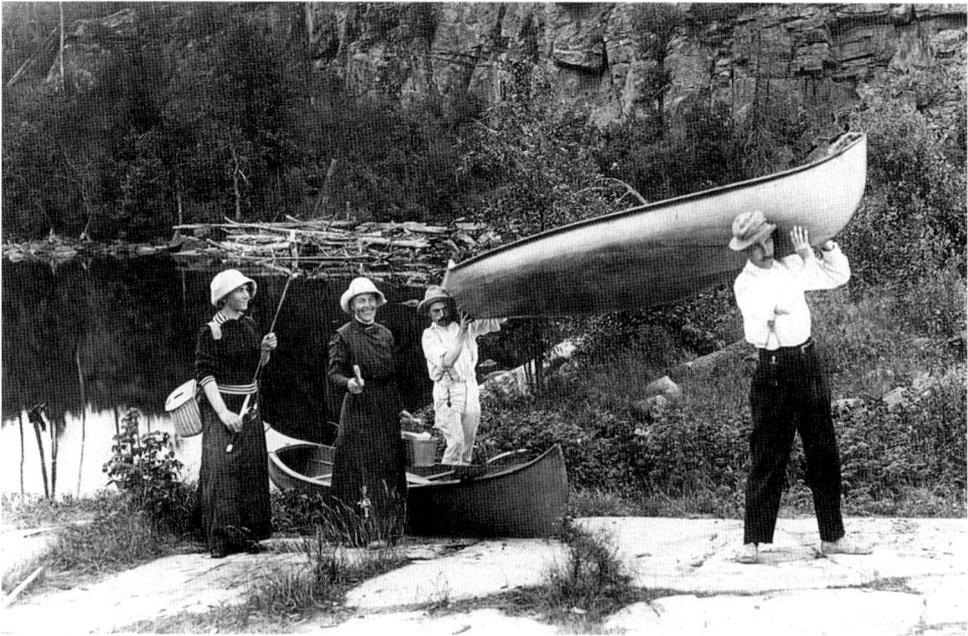

Timer photo, RB-CA.1

Doing a portage with one of these relatively heavy canoes resting on one shoulder
may have been more of a setup pose for the camera, than the reality of how Ernie
and Frank may have actually carried their craft. But despite the reason or the
method, this photograph is one of the most defining images in the entire
Rushbrook-Sherman Collection. It reflects the seriousness of Ernie (at the bow) and
Frank as they would have hoisted the canoe to their shoulders and then waited
for the shutter timer to release. Both men have rolled the brim of their hats back
so that their faces would be exposed to gain better lighting. Bertha (far left)
strikes one of the more serious poses than she usually demonstrates, the fishing rod
and creel over her shoulder appearing just a little less than a natural pose. And
then there's Ida. As the only one looking straight at the camera, grinning, and
pointing with the axe in her hand, this is a photograph of unusual and humorous
contrasts. As will be noted with other photographs that will follow, despite the
difficulties of capturing an image, these four people would take the time to shoot
the same scene again and again, hoping they would get at least one "keeper."
Circa 1911–12.

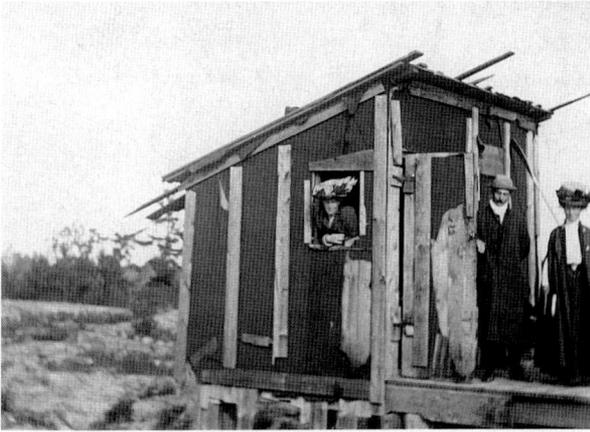

Left to right: Ida, Ernie and Bertha, c.1910–11. Waiting for the arrival of the motor launch that would take them up river to the railway station, they all appear tired and ready for the relaxation of the train trip back to Toronto. The crude tarpaper shack at the end of a dock at French River Village highlights a truth about living close to the land as the residents of the community did: functionalism is often more important than appearance.

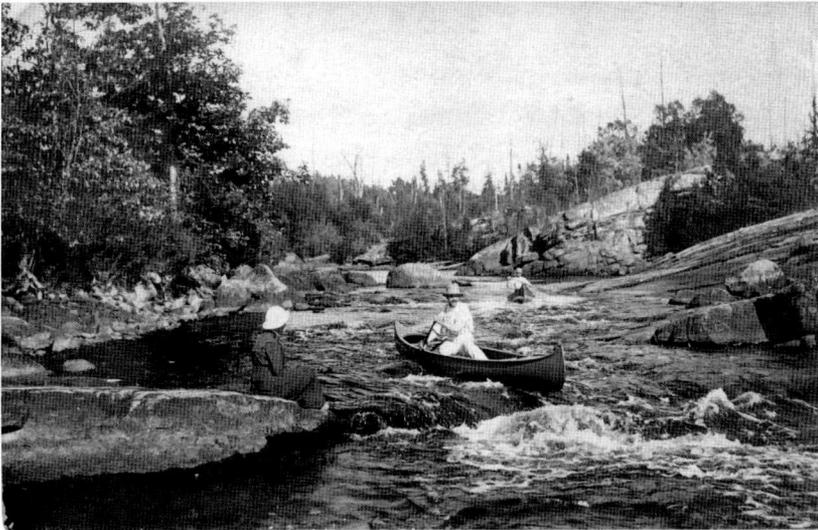

Bertha's photograph. RB-CA.14

This perfectly composed picture is a wonderful example of just how much these travellers enjoyed what they were experiencing, discovering and photographing along the French River. At least five separate shots of Ernie and Frank running these rapids exist. In each shot, something is different. Ida's position on the rock (at left) varies, sometimes Ernie is in the lead canoe, and in one exposure Frank and Ernie have put on different hats. All the shots were taken on the same 1912 trip. While there is not enough shadow definition to determine the amount of time that may have elapsed, no doubt by the time they lined their canoes back to the high side of the rapids and set up each shot, several hours would have passed. Left to right: Ida, Frank and Ernie.

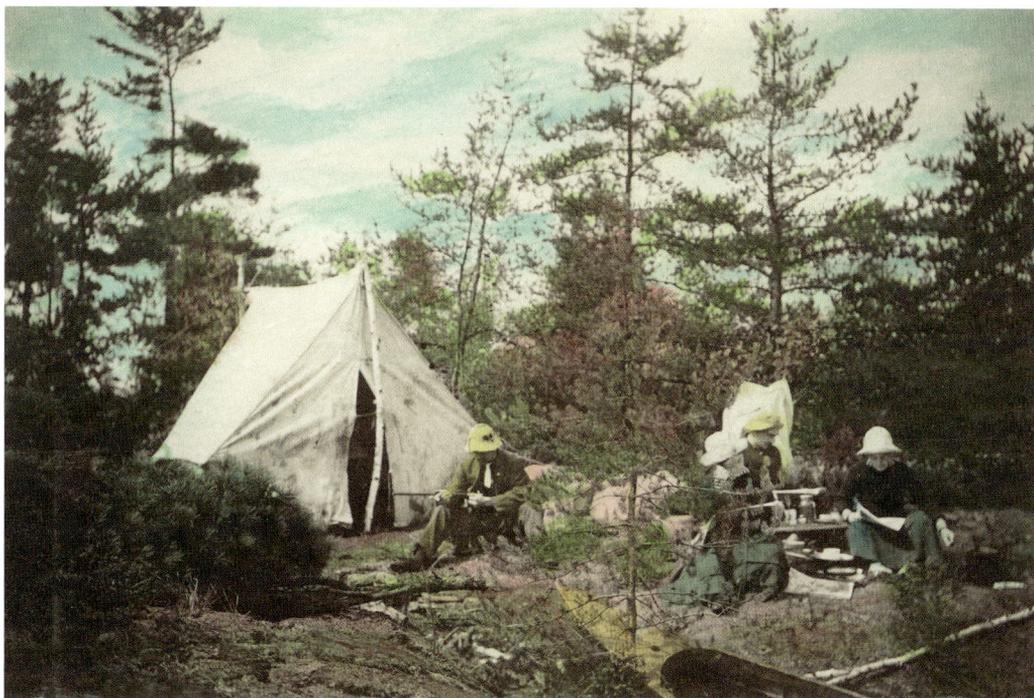

At camp, 1912. Left to right, Frank cleaning his gun, Bertha, Ernie and Ida.

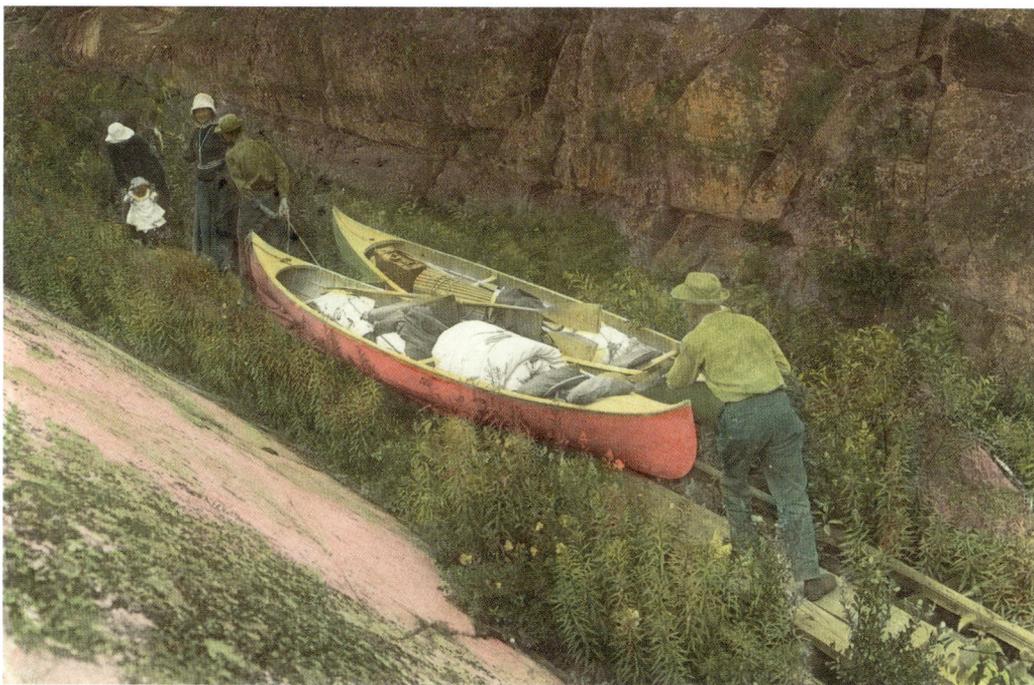

Portage over Dulles Rapids, 1914. Left to right, Ida with young Max, Bertha with a fish on a stick, Ernie and Frank. This is an interesting shot that details the significant amount of gear these travellers took on their French River trips. The roll of wooden slats in the green canoe was an expandable playpen system that served as a "cage" for the toddler.

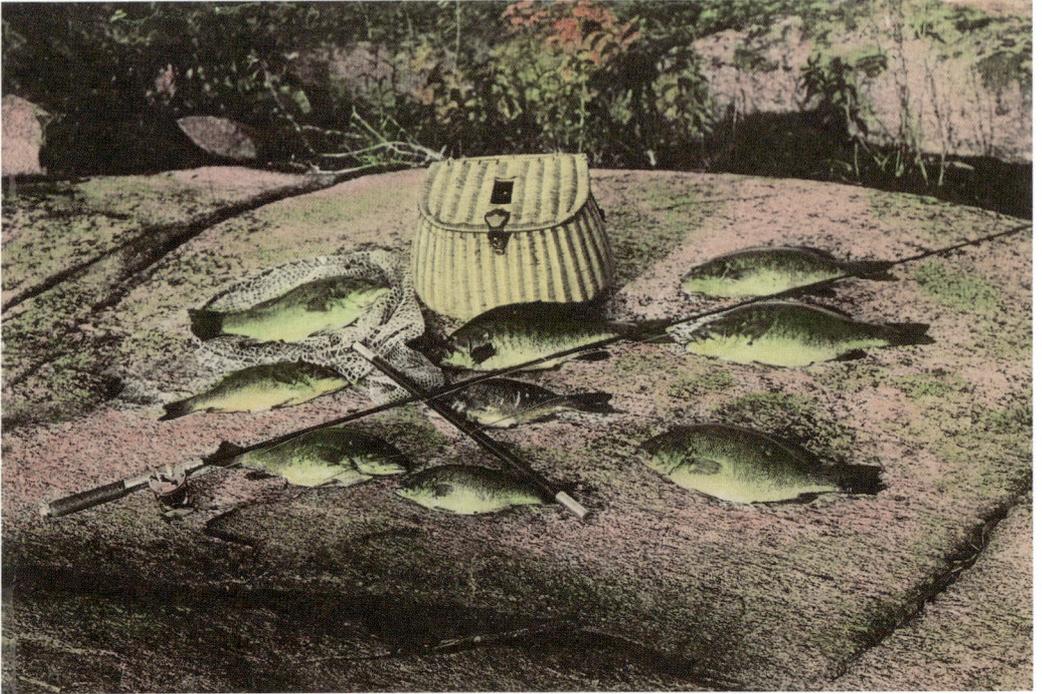

Bass on a rock, 1912. Frank or Ernie's photo.

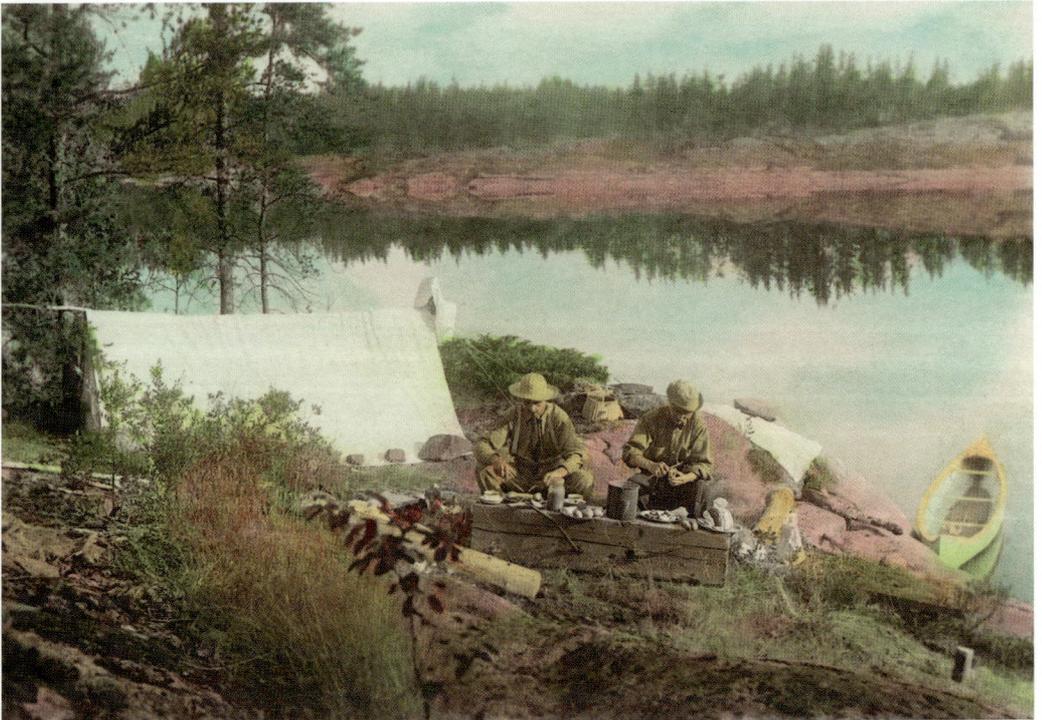

Frank (left) and Ernie preparing supper, 1912. The pink colour of the rock, as will be noted in other colourized photographs, is accurate. A geological curiosity appearing frequently in the French River region, the pink granite strikes an interesting contrast.

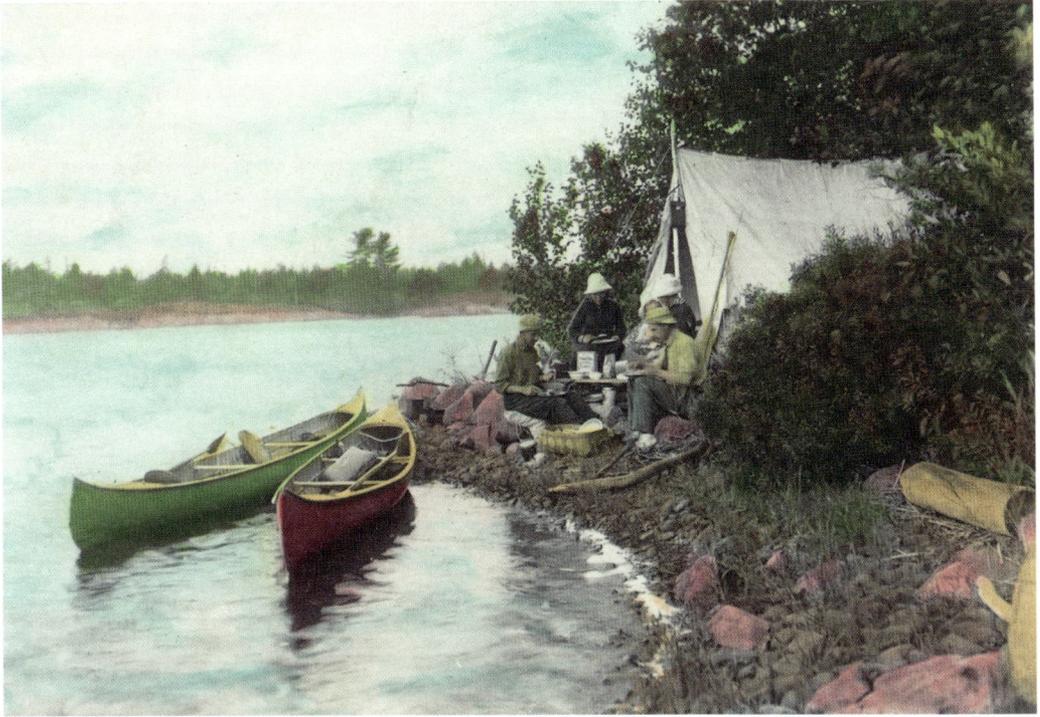

Camp on the French River, 1914, (left to right, Ernie, Ida, Bertha with Max, Frank). A box marked 'Toasted Corn Flakes' perhaps indicates this meal was breakfast.

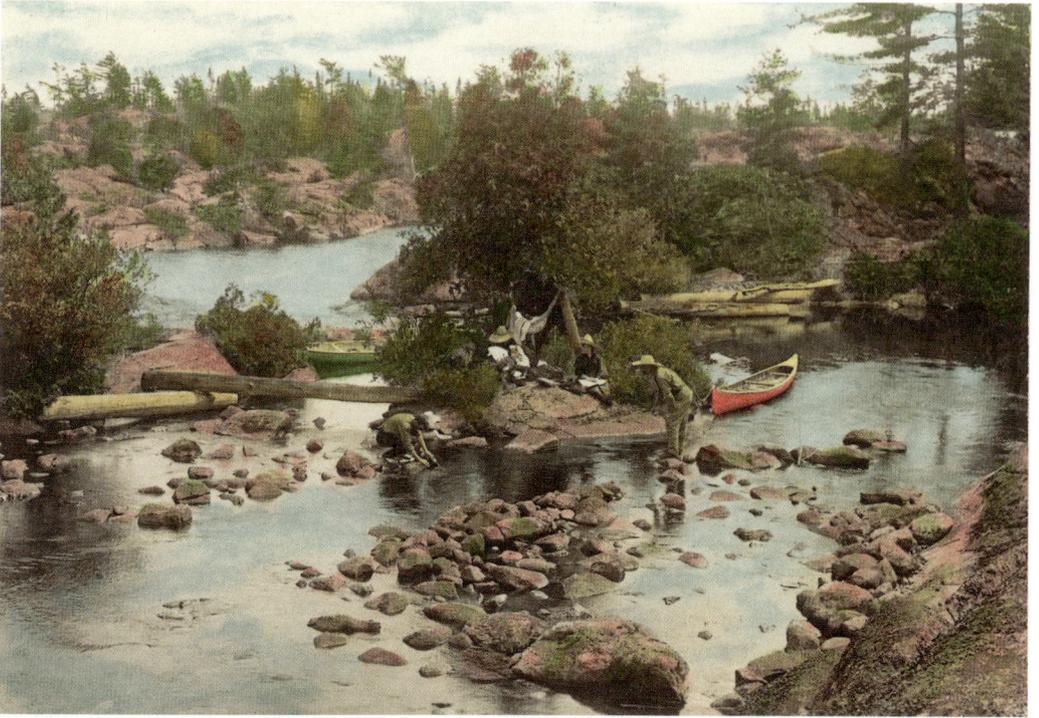

Shore lunch, 1914. (left to right: Ernie, Ida with Max, Bertha and Frank). With little evidence of gear in the canoes and not much more on shore, it would appear that this was a "day trip" away from their main camp.

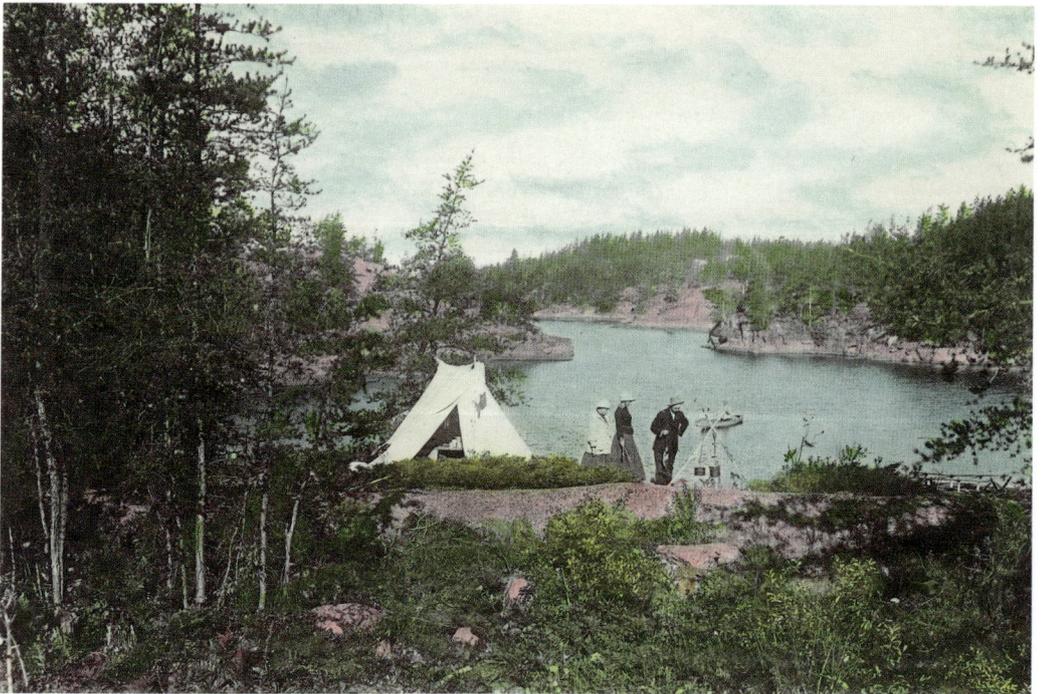

Left to right: Ida, Bertha and Frank. Ernie is in the canoe.

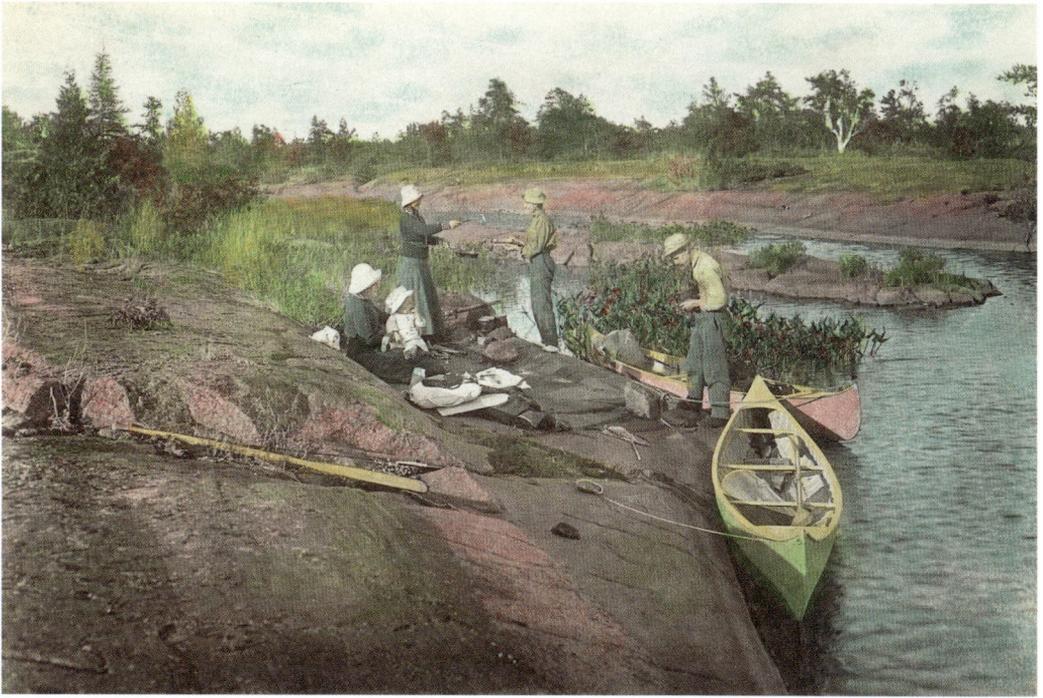

Left to right: Ida with Max on her knee, Bertha, Ernie and Frank with his Kodak, photo dated 1914.

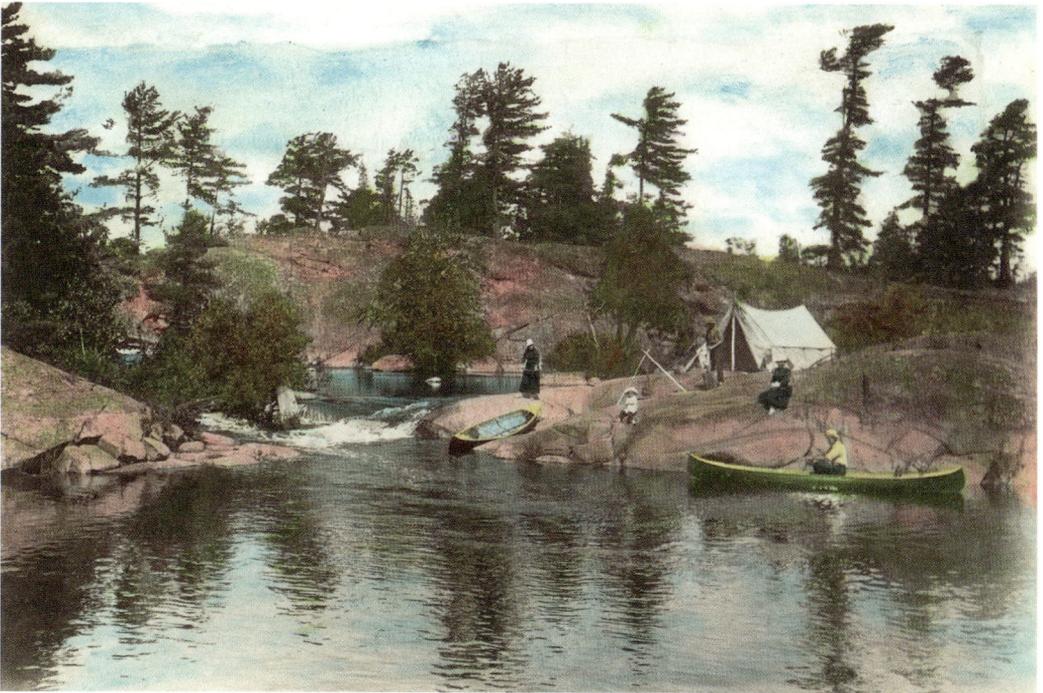

Another idyllic afternoon in a secluded cove on the French River. Max has his own fishing line. Ida is fishing from the shore, and Frank from his canoe. Earnie is splitting firewood and Bertha (far left) has a snake on the end of a stick.

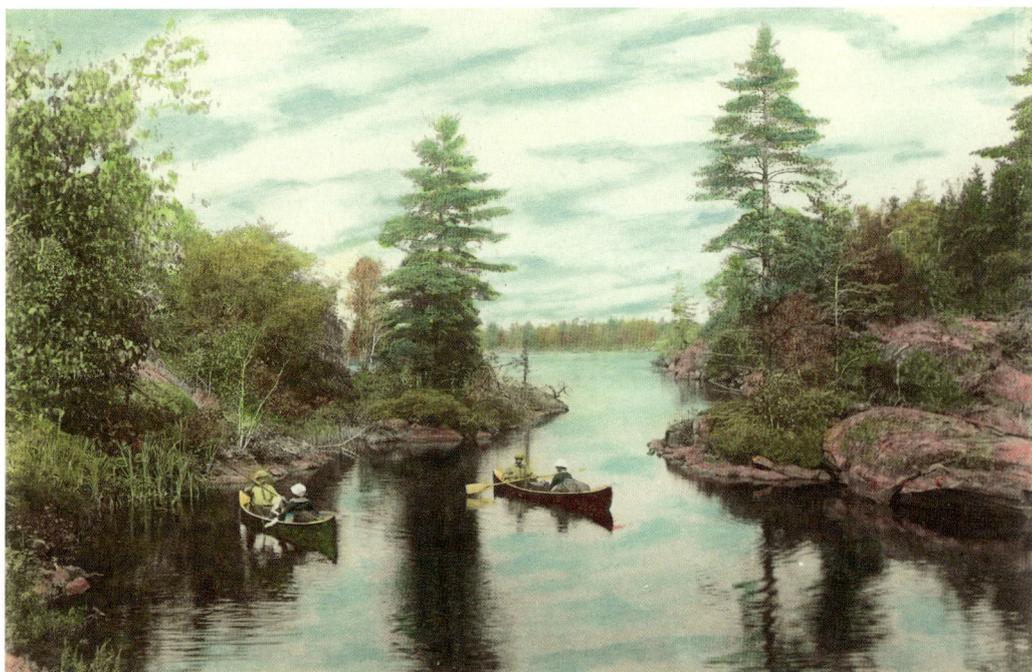

A quiet bay, 1915.

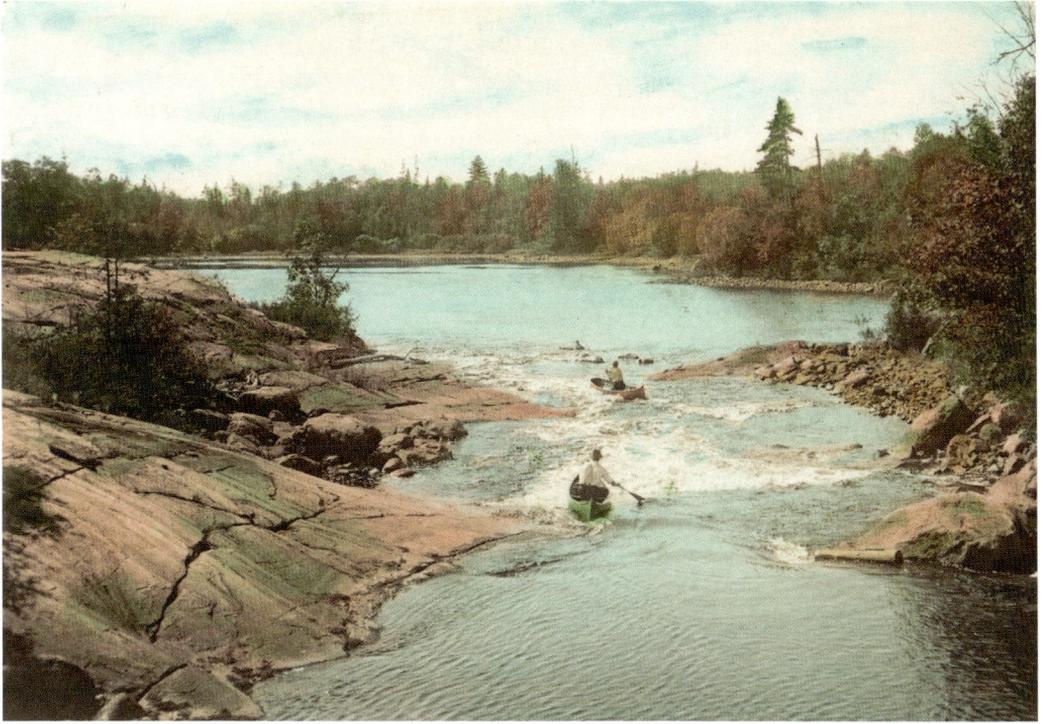

Ernie (in the lead) with Frank following, running a small set of rapids.

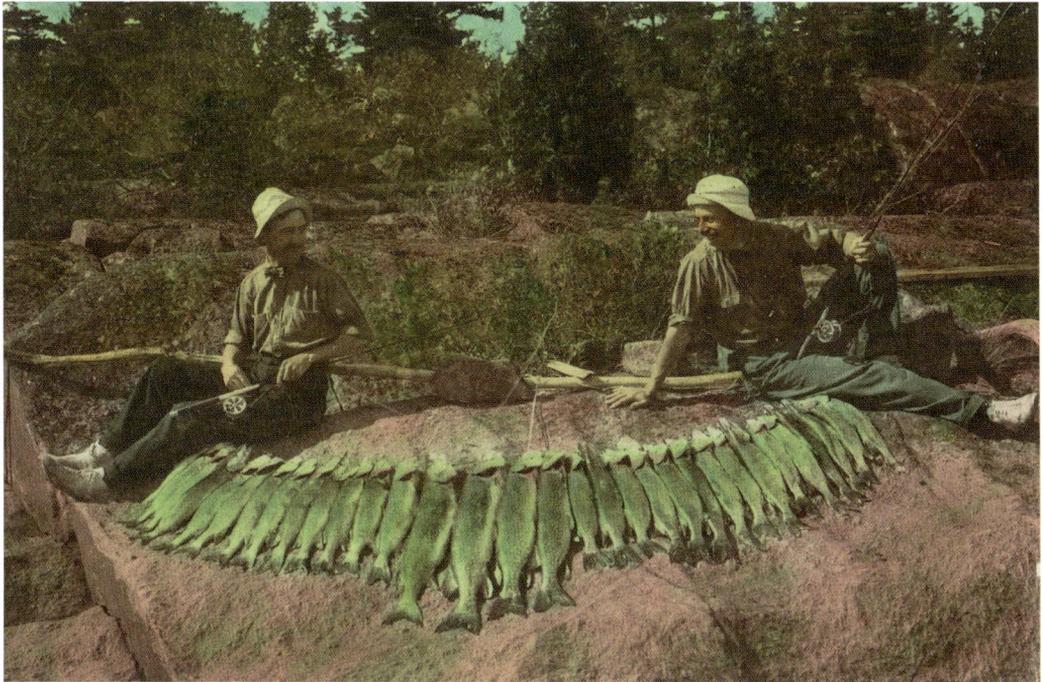

Ernie (left) and Frank with a great catch of fish.

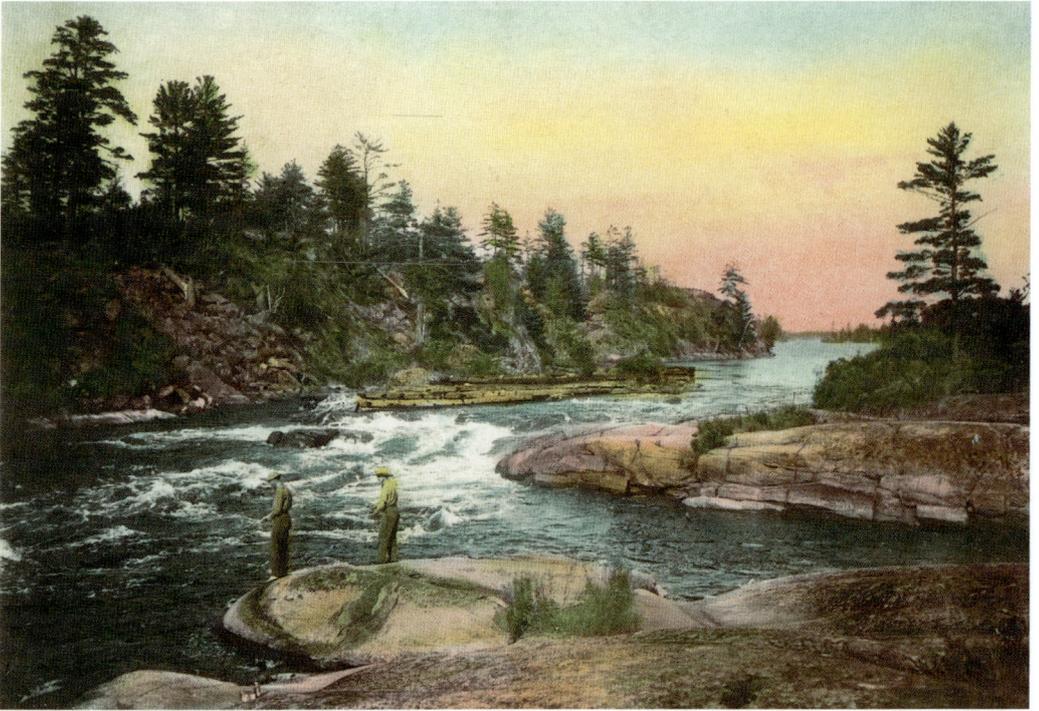

Ernie (left) and Frank, fishing near rapids.

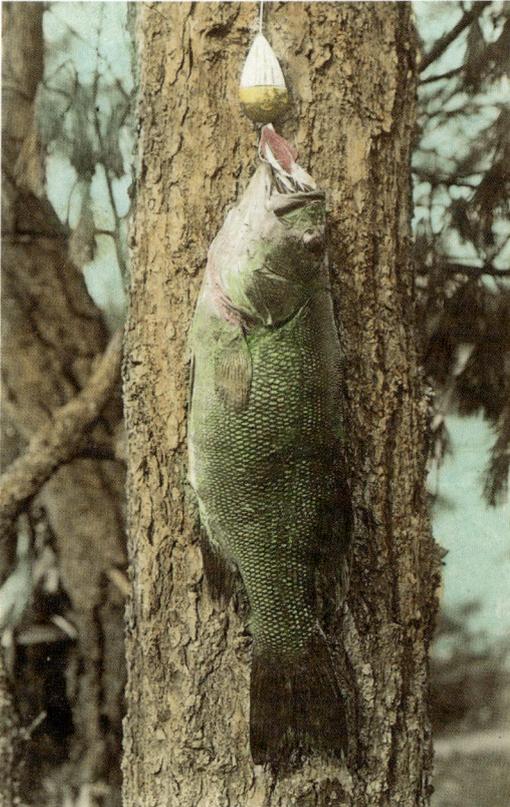

Walleye with lure, 1915.

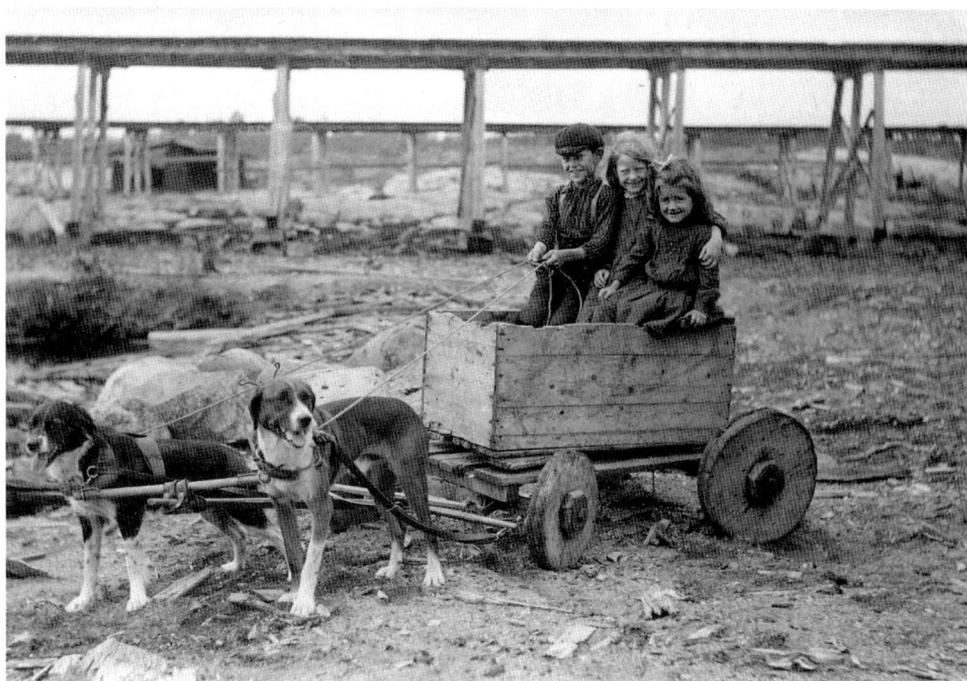

Ernie or Frank's shot, RB-DC.1

Dog cart with French River Village children, c.1912. The use of dogs as beasts of burden has a long history in this country. And while many people in southern Canada may not have personally experienced the dog cart in use, it was a highly practical mode of transport on the smooth, rock surfaces of the French River delta. The identity of the three children is not known, but the boy appears in several other photographs with different carts and different dog teams. One very telling photograph (not reproduced in this publication) shows a pair of dogs hauling a cart that has a 227-litre (50-gallon) wooden barrel of water and two boys riding behind. The combined weight must have exceeded 272 kilograms (600 lbs) and yet the dogs seemed adequate to the task. The two elevated tramways in the background were separated by a long narrow slip, or finger, of water that served as good shelter for canoes and smaller craft that frequented the waterways around French River Village.

PART FOUR

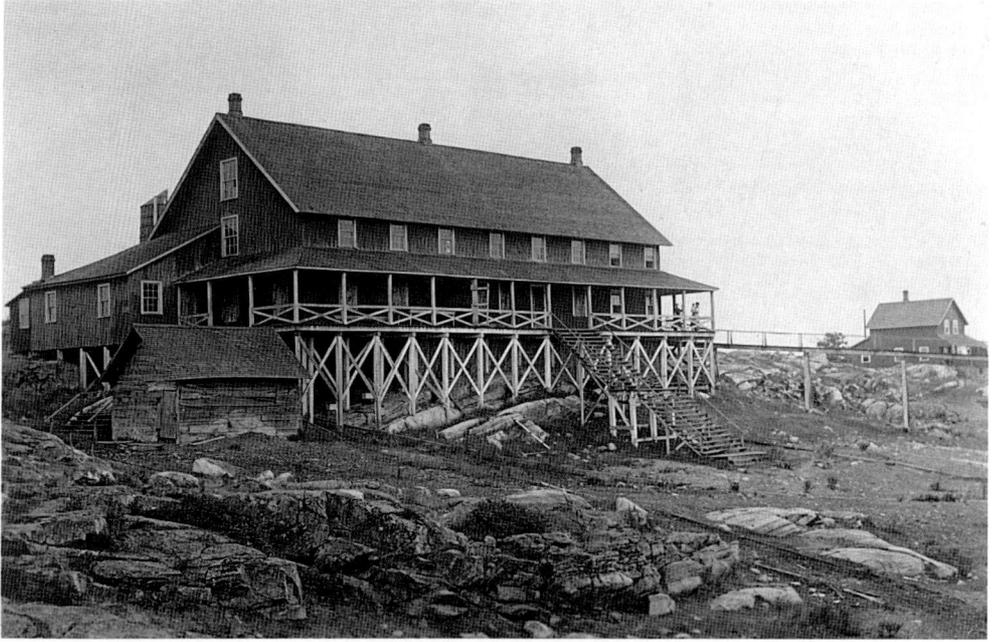

Next to the Ontario Lumber Company mill and incineration stack, the company's boarding house was one of the more prominent structures in French River Village. This view, looking east, was taken by Ernie or Frank in August 1914. At the far right end of the porch, Ida (left) and Bertha, holding young Max, can be seen. Since the mill had been closed for almost two years at this time, the boarding house regularly served as a hotel for travellers and tourists coming into the area. Occasionally, the Rushbrooks and Shermans rented rooms here for one or two nights, and just took "day trips" fishing and photographing some of the hidden coves and inlets in the delta region. As was the case throughout most of the village, almost all the buildings were constructed and anchored directly on rock, with no additional foundation necessary.

Death of the Village, 1913–19

The flow of the river is ceaseless and its water is never the same.
The bubbles that float in the pools, now vanishing, now forming are not
of long duration: so in the world are man and his dwellings.
– Kamo no Chōmei, *Hojoki* (An Account of My Hut). 1212 C.E.

With its 15-metre-tall chip and sawdust burner dominating the landscape as the most visible feature that a traveller might see when approaching French River Village from the south, the Ontario Lumber Company had certainly seen some good years. The demand for the lumber products they produced had been high. A hungry domestic and export market had provided income that handsomely lined the pockets of both management and employees alike at the isolated village mill. But the timber resource that had seemed inexhaustible for thirty years, began to send a wake-up call to mill owners as the second decade of the twentieth century began. The cry from nature, however, was first heard not from the land but from the water.

Commercial fishing had existed in Georgian Bay since the 1830s. As the scope of the industry widened, co-existence with the timber business in the northeast corner of the bay began to feel the winds of conflict. By the mid-1890s, the company that would become the largest fishing concern in the area, Gauthier Fisheries, had located a few docks and processing shacks at the very mouth of the French River. But the

heavy traffic flow of cargo ships in and out of the French River Village harbour and the constant potential of getting nets entangled with the rogue logs that kept escaping from the booms upstream in MacDougal Bay, was an ongoing source of concern. Ultimately, the owner of the small business, Charles Gauthier, was motivated to relocate his operation about five kilometres further west, at Bad River Point, away from the mouth of the French.[1]

Gauthier had been born in Windsor, Ontario, and from a young age had been no stranger to the ways of fishing. As he wet his line in the waters of the Detroit River and Lake St. Clair, he dreamed of owning his own fishing business and running a fleet of boats in the Great Lakes. In time his dreams were realized and business progressed. By 1916 Gauthier Fisheries owned an 18-metre steel tug, the *Edith Gauthier* (named after his wife), an 11.5-metre tow boat, four 9-metre fishing boats and two scows. With a fishing outpost located on the Bustard Islands, just a few kilometres south of the mouth of the French, and another on Champlain Island, business seemed good.[2] Fish of many species were plentiful and the market was relatively stable. But around 1910–11 commercial fishermen all around Georgian Bay began to grumble. It was becoming obvious that tons of sawdust from the large number of mills scattered along the shores and mouths of rivers that emptied into *La Mer Douce*[3] were choking the gravel bars and spawning beds. Fish stocks were in decline. Fishermen were hurting. The cry reached Queen's Park in Toronto, and with swift action seldom seen in governments of the time, the provincial legislature passed a bill restricting the amount of sawdust and slash lumber that could be discharged into Ontario waterways. This act constituted some of the very first pollution control legislation in Canadian history.[4]

The Ontario Lumber Company's operation at French River Village was targeted severely by the new laws and received a heavy fine for their part in the apparent suffocation of fish-spawning beds. The new restrictions, combined with the fact that many timber rights and licences around the bay were expiring and that companies were having to send loggers further afield to keep the floating booms at the mills full, was sending the lumber industry into a nose-dive. In addition, with the recent arrival of both CPR and CNR rail lines in the area, logs and

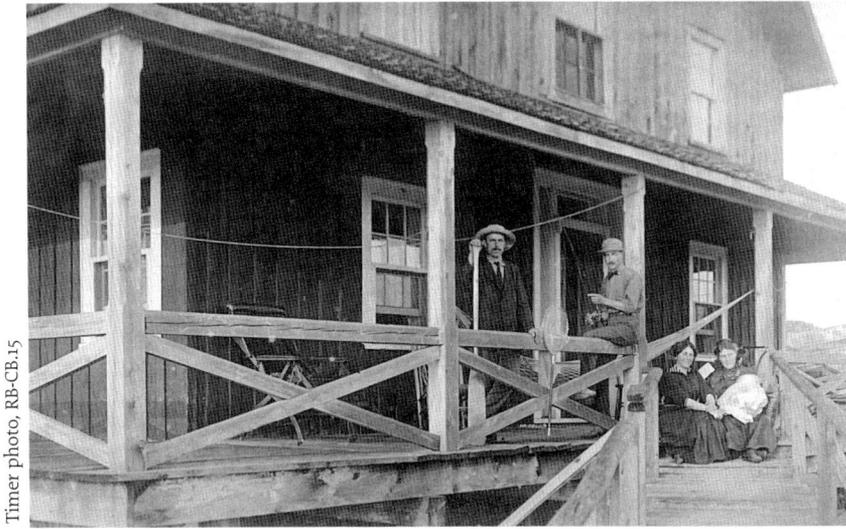

Timer photo, RB-CB.15

August 1913. The Ontario Lumber Company boarding house was located in the most southerly portion of French River Village. Seen left to right: Frank, Ernie, Bertha and Ida, holding three-month-old Max, plan the day's activities on the south porch of the building.

lumber could now be transported on railway flat cars. Winter ice in the rivers and vicious storms on Georgian Bay and the rest of the Great Lakes, combined with rail freight rates that were more competitive than those the ship companies were offering, drove many mills away from the area. By early 1913, the Ontario Lumber Company at French River Village was in receivership.[5]

While numerous sources suggest that the entire Ontario Lumber Company sawmill was purchased by the Pine Lake Lumber Company, dismantled, numbered piece by piece, and moved to Pickerel Landing Village in 1913, existing photographs from the Rushbrook-Sherman collections show the large mill building with its slash and sawdust incinerator still standing as late as 1917. Perhaps the clarification that needs to be made can be found in understanding what is meant by the term "sawmill." As is the case in many parts of Canada down to the present, it generally defines just the equipment – the power source, the saws, conveyors and machinery – associated with such business, *not* the buildings or, in many cases, perhaps just a roof to keeps the rain and snow at bay. Likewise, the tall stack of the incinerator that dominated the skyline at

Entitled "Trip Expenses French River, 1913" many of the grocery items
that had been listed in the 1912 log were omitted. The 1913 account
showed the items as noted:

Four tickets C.N.R. $33.00
Four single paddles 6.00
Express on double paddles .50
Boys at Union Station .20
Plates and chemicals 9.00
Kodak films 23.00
Photos to Mr. Udy and B. Cates 2.10

French River Village remained standing for many years after the closure
of the mill. Sawdust and slash burners are little more than big wood
stoves. Manufactured from sheet metal, their lifespan at the hands of
rust and intense heat is short. The disassembly and rebuilding of that
aspect of the Ontario Lumber Company mill would no doubt have been
ill-advised. In 1916, however, the Toronto firm, York Wrecking Company,
was engaged to dismantle some of the better homes and buildings as
they were apparently considered an insurance liability. While a few of
the structures may have been reconstructed in the area, the majority of
the building materials were dispersed through demolition liquidators.

Despite the closure of the mill at French River Village, and the fact
that most of the population had packed up to seek greener pastures,
several hundred residents remained in the community for the next ten
to fifteen years. Fishing, trapping, small-scale lumbering and a seasonal
tourism business that lured anglers and hunters to the area, continued
to offer subsistence living for most of the families that had decided to
remain. With that limited infrastructure in place, Ernie, Ida, Bertha and
Frank continued to make annual visits to the area and enjoy the natu-
ral habitat that persisted. Having used the CPR station at Pickerel
Landing Village as a starting point for several of their early trips into the
area, by 1913 Ernie and Frank decided that the community of Pickerel
River (CNR) was closer and more accessible to the French and Pickerel
River systems that they enjoyed exploring.[6]

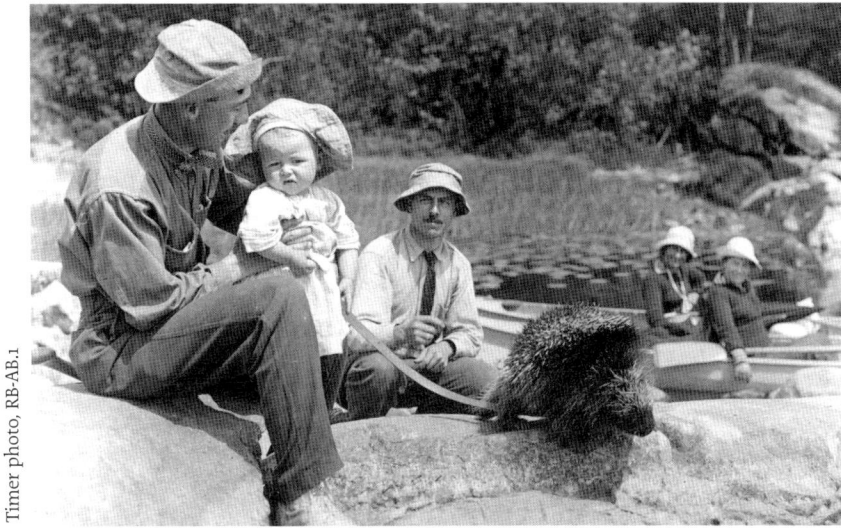

Timer photo, RB-AB.1

Porcupine on a leash, 1914. As reluctant as little Max appears, the critter was no doubt more reluctant to pose for this shot. From left to right: Ernie, Max, Frank, Bertha and Ida. While Daddy (Frank) and Uncle Ernie, sporting his favourite polka-dot bow tie, appear poised for immediate action if the animal turned, Mother and Aunt Ida seem to have little concern. (So just what method is used to put a leash on and take a leash off a porcupine?)

The year 1913 marked a significant addition to the fearsome four-some who already had three years worth of French River expeditions behind them. Bertha and Frank were blessed with the arrival of a healthy baby boy on May 17 of that year. Maxwell Kelvin Sherman (known through his life simply as "Max") could be described as a child who literally "cut his teeth" on the shaft of a canoe paddle. Would Bertha stay at home with baby Max the coming August when the now annual canoe trip would take place? Not a chance! Even while they were running a few small rapids, the little "treasure" was bundled in white wool blankets and held close by either his mother or Aunt Ida but sometimes just placed on the rib boards in the bottom of the canoe. No PFDs (Personal Floatation Devices) in sight; no 1912 Titanic-style kapok life preservers. On a river system where a heavy rainfall can raise water levels by as much as a metre within a few hours, the risk of capsizing was ever present. Hypothermia was alwats possible, especially for an infant. Wolves, black bears, blackflies, mosquitoes and the eastern

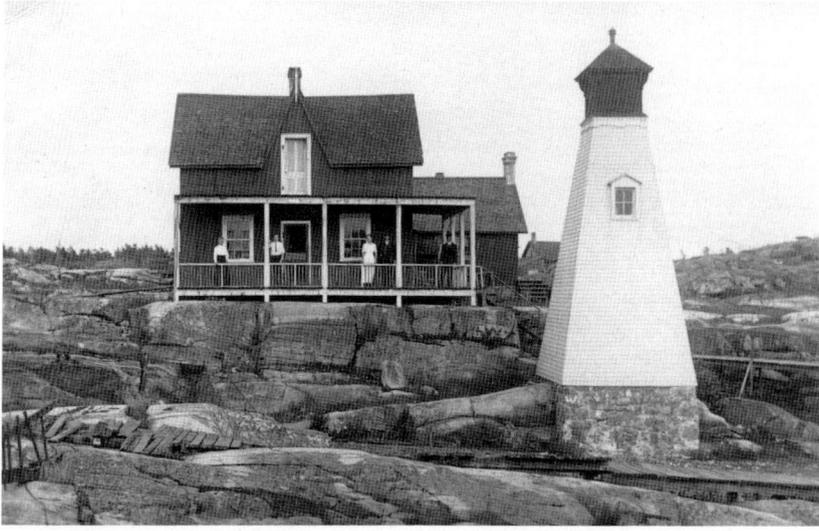

Originally in use as the lighthouse-keeper's home, this building, evidence suggests, became the home of Dean Udy and his family after the Ontario Lumber Company left the village. At far left is Mrs. Udy. The others are not known. The remains of a board sidewalk are visible at the bottom of the photograph as is the harsh rock terrain upon which all structures at French River Village were assembled, c. 1914–15.

Massasauga rattlesnake all inhabited the French River delta. The Shermans and Rushbrooks were either fearless or simply naive.

Max was a very photogenic child. And his parents knew it. He is pictured in dozens of locations and dozens of camping, fishing and canoeing scenarios through the period from 1913 to 1927. And while the majority of the Rushbrook-Sherman Collection photographs have trips to the French River – a family ritual – as a backdrop, there is much evidence in letters and postcards to indicate that canoe trips were also made into the Pickerel, Moon and Key rivers, as well as to Tobermory, Lion's Head, Honey Harbour, Killarney, through Lakes Rosseau and Joseph in the Muskokas, and at least one trip down the Ottawa River. Unfortunately, however, very few photographs from those trips or locales exist – with even less detail as to the reason why.

Among the twelve little tykes born to George and Eliza Rushbrook, Ernie and his twin sister, Ethel, had been the tenth and eleventh children, respectively. Bertha was the youngest. On December 19, 1912,

A handwritten receipt from Dean Udy to Ernie Rushbrook, August 21, 1916.
From the content of the bill, it was obvious that the Rushbrooks and Shermans
had stayed at the French River Village boarding house for at least a portion of
this trip, since rooms had to be cleaned. With an entry indicating canoes had been
painted, it may be that Ernie and Frank had requested particular canoes for this
trip that required attention to make them water worthy. The entry for gasoline
may have been part of Dean's cost to ferry the visitors to or from a railway station
with his motor launch.

Ethel had been killed in a tragic accident when she inadvertently
stepped into the path of a Toronto streetcar. She was 34 years old at the
time. In modern days we have come to appreciate the close bonds that
exist between twins and have even more understanding and empathy
for the trauma that a surviving twin experiences when his closest sib-
ling dies. And while we may see some of those emotions on the face of
Ernie from 1913 onward, the bond of kinship with his sisters Ida and
Bertha, the strong relationship he had with his friend, brother-in-law
and professional colleague, Frank, and the obvious delight he took in

his young nephew, Max, were no doubt of significant comfort to him during the dark period of his mourning. But as day follows night and sunshine dispels darkness, Ernie found even more comfort in the arms of his young wife, Alma, when they were wed in 1917. Ten months later, in October 1918, Gordon Ernest Rushbrook was born into their union.

Very few photos of Alma on canoe trips have survived, and only a handful of pictures reveal Gordon's presence on such trips, and not until he was about eight years of age. This may be due to the fact that Gordon was a rather sickly child and suffered from significant health issues throughout the balance of his life. And while Ernie mailed very touching postcards and letters home from his French River expeditions in the ensuing years, indicating that he missed his wife and young son desperately, it was obvious that he did not allow his family circumstances to keep him from occasionally indulging in his canoeing and photography pleasures.

So while the small village at the mouth of the French River was dying, while a troubled world entered into the Great War, and although personal loss had invaded the peaceful lives of the Rushbrook and Sherman households, new life and new opportunities were emerging before their eyes. The 1913–19 trips were some of the best years of their lives.

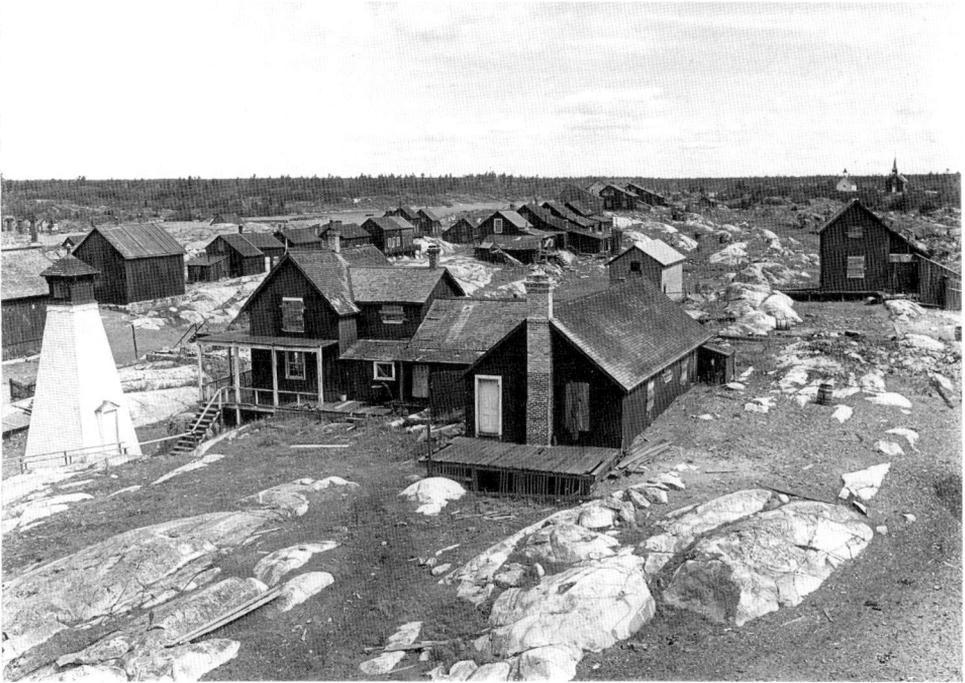

Ernie or Frank's photo, RB-OS.4

French River Village, summer 1914. As can be noted in the photograph, a number of buildings have had their windows boarded up. The building closest to the camera (at centre) housed the Ontario Lumber Company's store and employee recreation hall until the firm was placed in receivership in early 1913. The lighthouse, at left, is the only structure still standing at present. Just below the horizon (top right) the Presbyterian and Roman Catholic churches can be seen. Most of the buildings running along the river were mill workers homes.

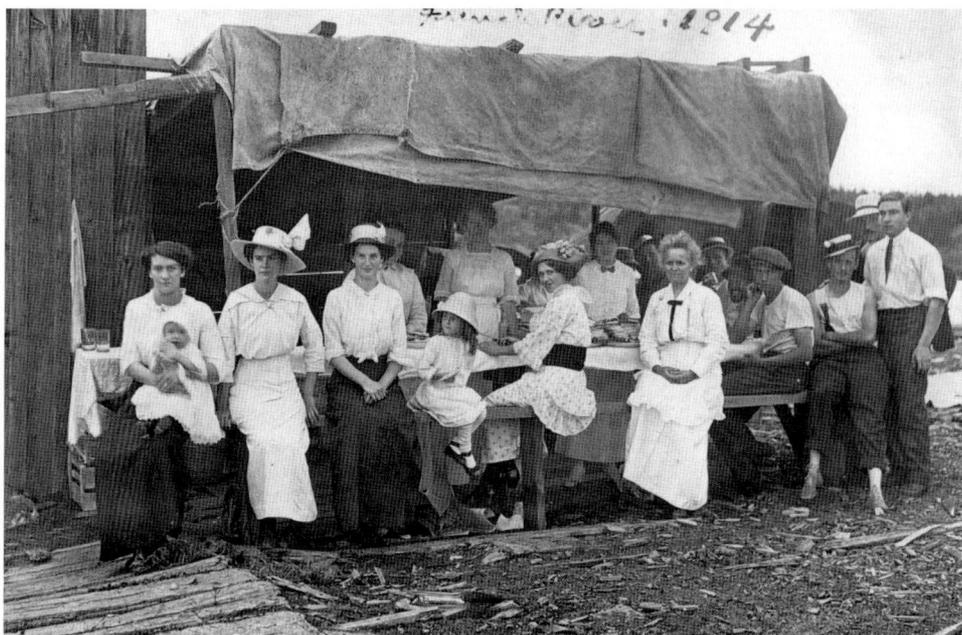

Ernie or Frank's photo, RB-MP.1

This is one of the few photographs in the Rushbrook-Sherman Collection to have a location and date inked on the photo surface The folks pictured here are all French River Village residents. Mrs. Udy (first woman from the right) is the only one identified. Several other photos (not reproduced in this publication due to relatively poor quality) feature some of the men who appear at the right side. They are shown in those photographs participating in a pie-eating contest, hands tied behind their backs and face-first into pies that were placed on the ground. From the drinking glasses, food preparations on the table and the finery in which the women and children are dressed, a special event must have been taking place in the village, August 1914.

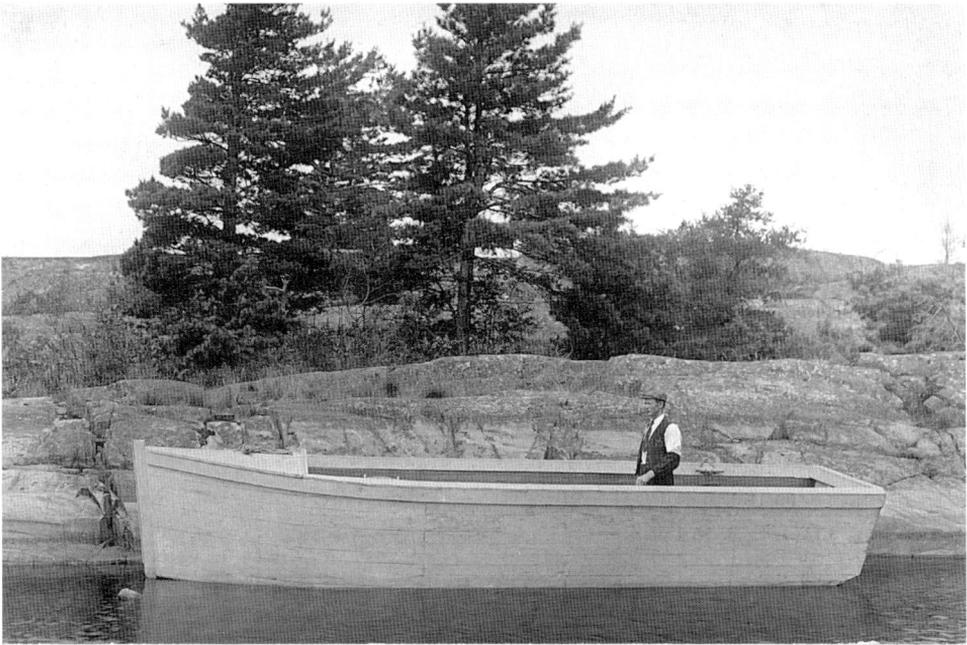

Ernie or Frank's photo, RB-BB.4

*Dean Udy's homemade motor launch, c.1914. A cumbersome vessel, it no doubt
had a hauling capacity of many tons. As recorded in one 1919 document, Ernie
and Frank travelled in this craft with Dean out to the Bustard Islands (a few kilo-
metres south of the mouth of the French River in Georgian Bay) to help him pick
up a load of supplies for the village. A man who "wore many hats," Dean served
as storekeeper, postmaster, outfitter, guide, village constable and jailer, dog-cart
manufacturer, part-time lighthouse keeper, hotel manager and "Mr. Fix-it"
around the village until 1922. He also used this boat and a slightly smaller motor
launch to pickup tourists like the Rushbrooks, Shermans and others who arrived
at the railway stations east of French River Village.*

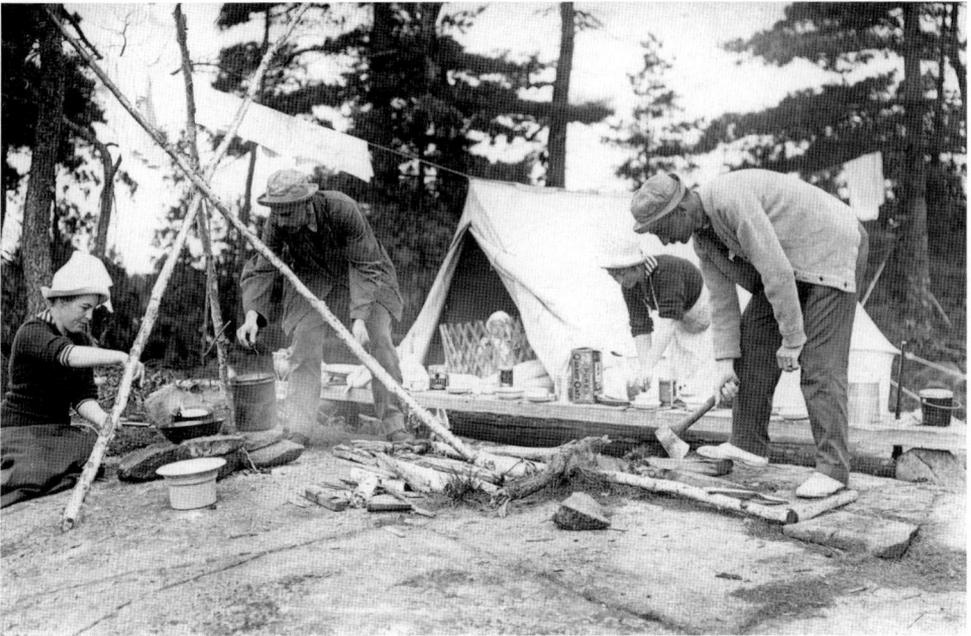

Timer photo, RB-CT.1

Camped somewhere near French River Village, the folks in this photograph are posed in a working profile. Left to right: Ida, Frank, Bertha and Ernie. Fifteen-month-old Max can be seen playing in his "cage" in the tent. On the log bench-cum-kitchen table, we can see a box of Quaker Oats and a can of coffee. No doubt Ida is tending to fish in the skillet. A few cloth diapers adorn the tent lines, and Frank's rifle is seen leaning against the bench at the far right. While there is no record that these travellers ever encountered a black bear – common in the delta area – taking the precaution of having a firearm available was practical in this era, photo dated 1914.

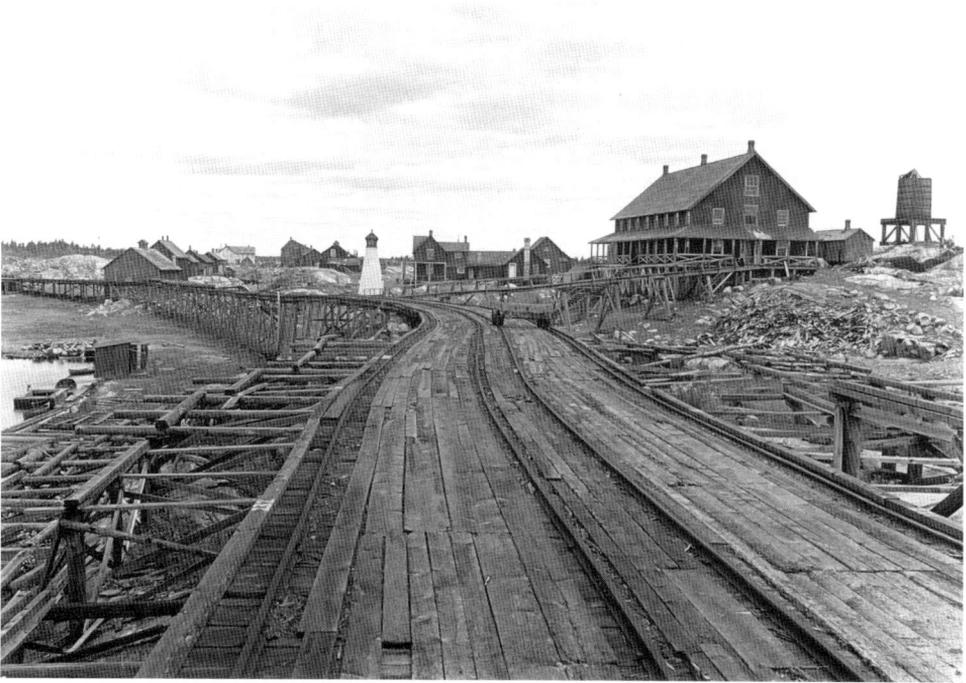

The elevated tramways used by the Ontario Lumber Company dominate not only this photograph; they dominated French River Village. With a span between the rails of more than two metres, this was not a trestle for train traffic, as a few documenters of the village history have concluded. Trains never came to the village. The standard rail gauge in North America is 1.435 metres. The broad gauge design shown here was meant to accommodate the wide-stance lorries (as seen on the track at the right side in the centre of the picture), and carried large loads of freshly milled lumber from the sawmill to the cribs and support racks (as seen at the lower left side) where they were easily accessed for loading onto ships that would transport them out into Georgian Bay, to the Great Lakes and beyond. The large building at the right was the Ontario Lumber Company bunkhouse, later a modest hotel. Following the tramway far down around the bend to the left would have led to the mill itself. The large, light-coloured building with gables on the roof, as seen at the very back of the picture on the left side, close to the horizon, was the Queen's Hotel. A further photograph that follows shows that building being razed by fire. Photo of tramways dated 1915.

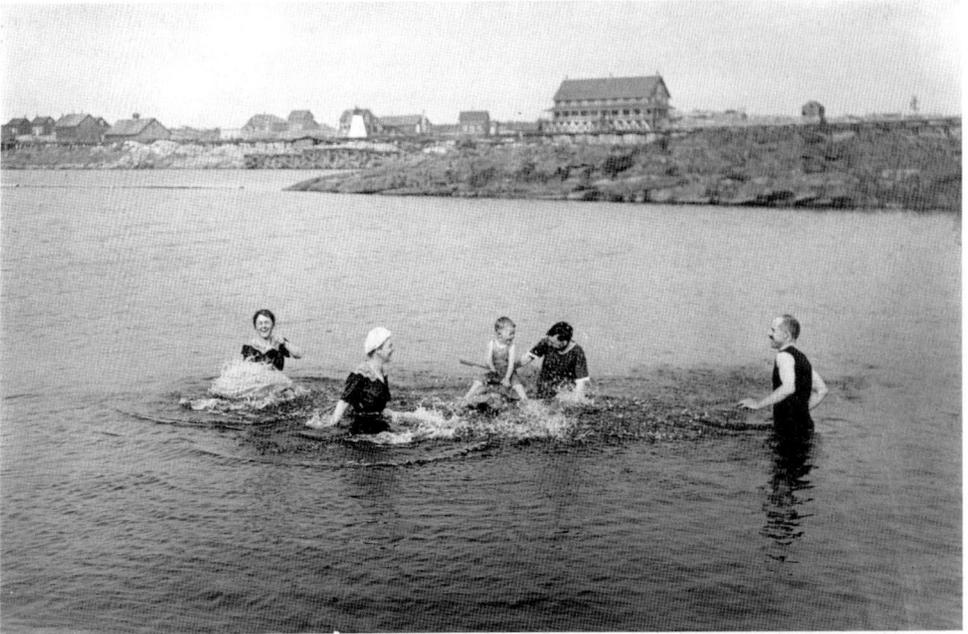

A swim in the French River, 1916. Looking east across the river channel, the former Ontario Lumber Company's boarding house looks impressive as shown here on the horizon of the village. The reality was that the building was quickly deteriorating. It was to vanish from the scene within just a couple of years. The bathers (from left to right) are Bertha, Ida, Max on a log, Ernie and Frank. The close proximity of Ernie and Ida to their young nephew, Max, occurs in the majority of the surviving collection photos during the period of his first six years. Ernie and Ida very obviously treated the "little guy" as their own child.

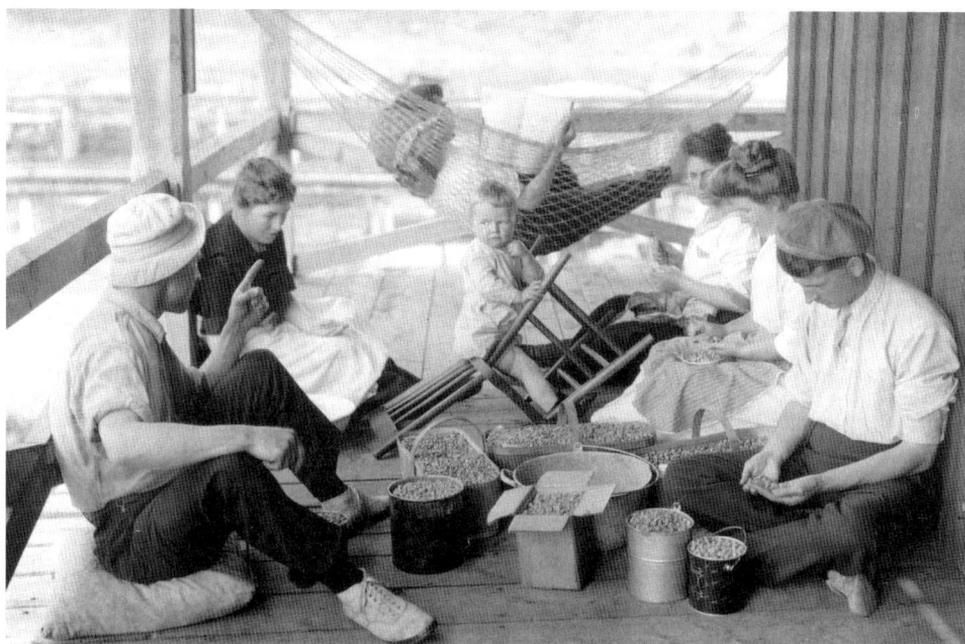

Timer photo, RB-MW.1

On the south porch of the boarding house, the 1916 blueberry harvest is sorted for processing and preserving. Shipping salted fish and boxes of blueberries south to Toronto by train was an annual rite observed by the Rushbrooks and Shermans. Occasionally, Ida and Bertha would jam and jar blueberries while staying at French River Village, transporting them home in their large steamer trunk. From left to right, around the circle, Frank, Ida, Ernie (in the hammock), Max, Bertha, and an unknown village couple who appear in several of their photographs. While the purpose of the scolding that Frank is delivering to young Max is unknown, it was most likely Frank's ploy to get Max posed "just right" for the shot. The long cotton stockings affixed with garters to Max's clothing may have been more for the purpose of insect protection than warmth.

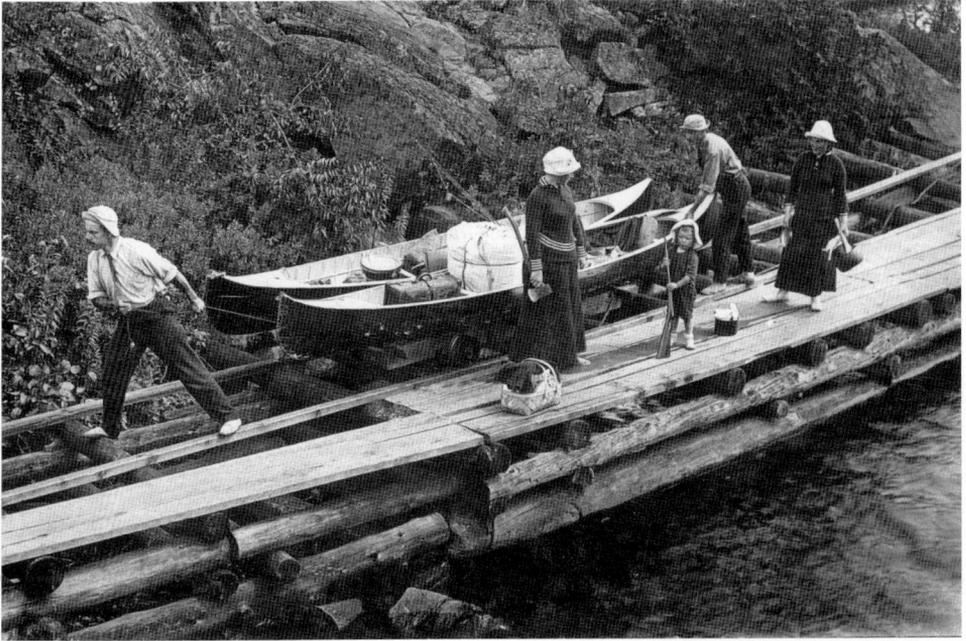

The location of this photograph is possibly the tramway that had been constructed to bypass the Dulles Rapids, just northeast of French River Village. A tramway had been built there in 1907 to allow the Canadian Pacific Railway to transport some of the building materials, ties and rails needed in the construction of their bridges across the French and Pickerel rivers further upstream. An excellent way to portage heavy canoes and gear, the Dulles tramway was not maintained following the rail construction era, and little evidence of it exists today. On the other hand, a 240-metre tramway, just two kilometres southeast of French River Village at Bass Lake, still exists and has been maintained in recent years allowing canoeists a pleasant portage experience while tripping in that area. This photograph is wonderfully typical of the way these intrepid travellers set up their shots. Everyone is posed in a work position of carrying, pushing or pulling. Even little Max has been given charge of the rifle and no doubt warned by his mother to "stand still" due to both the rifle and his nearness to the edge of the tramway, but also awaiting for the sound of the shutter release. From left to right: Frank, Bertha, Max, Ernie, and Ida, photo dated 1917.

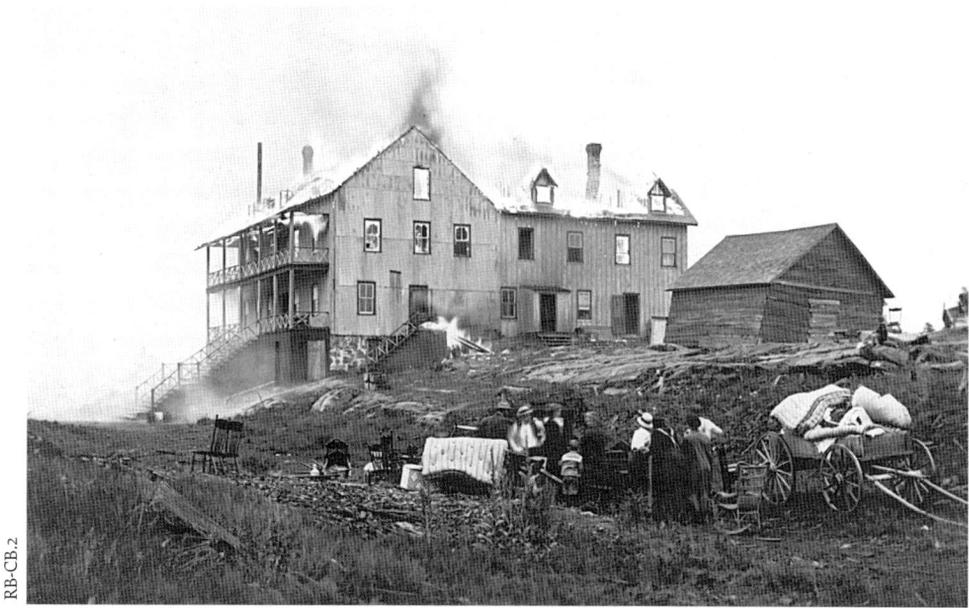

RB-CB.2

The Queen's Hotel fire, French River Village, c.1917. In a series of five photographs showing the fire that razed "the best hotel in town," this image was the first one captured by Ernie or Frank, either of whom must have been on shore and in the village when the fire began. The distance from the boarding house/hotel and docking area that they customarily used was about one kilometre, south of the Queen's. A run up to the area, with cameras in hand, must have sent adrenaline rushing as they looked on helplessly, and were too late to assist village residents who had abandoned hope of rescuing more furniture or fixtures from the once-grand – for the time and place – hotel. The cause of the fire was unknown.

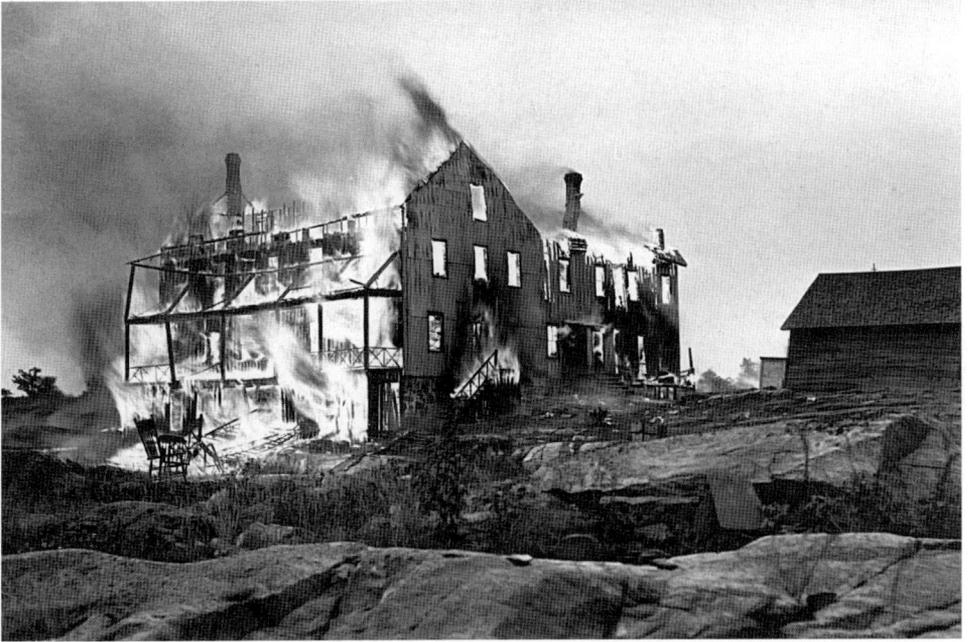

RB-CB.1

The Queen's Hotel fire, French River Village, c.1917. The rear chimney is about to collapse and the building is in full blaze. This was the third in the series of shots taken by Ernie or Frank as the thirty-year-old structure was in its death throes. Not much seemed to matter in the village following this devastating fire. While local residents had been struggling to scrape a living out of the rocky landscape since the mill closed, the loss of this local landmark seemed to "rubber stamp" the inevitable. By 1919 only a few dozen families were left in the village.

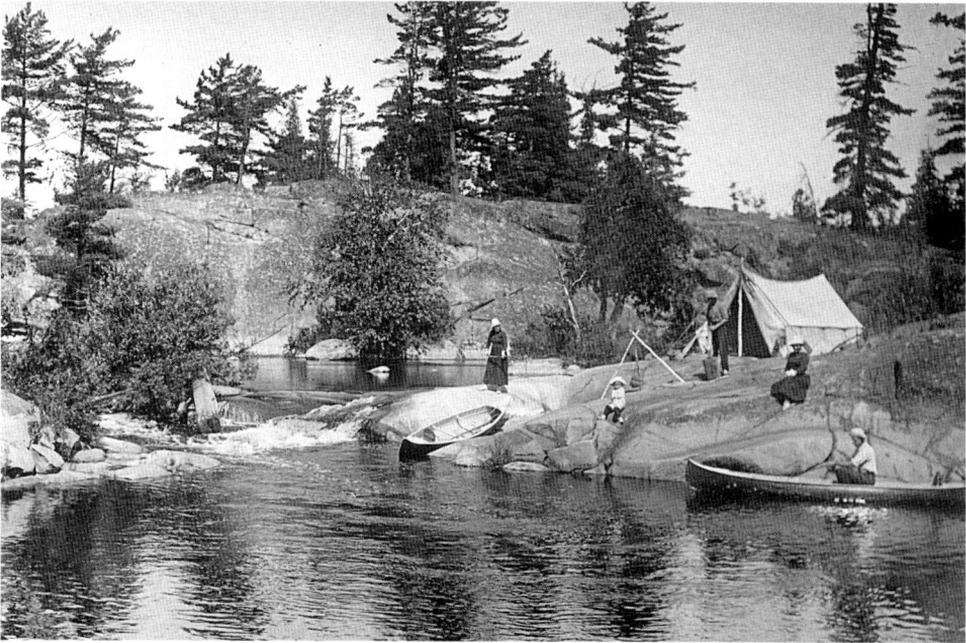

Timer photo, RB-CT.17

Another idyllic afternoon in a secluded cove on the French River. The family sometimes encamped for three or four days in a location like this, taking leisurely canoe trips to fish and photograph along the small inlets and creeks that lazed their way into the larger river. One can almost feel the peace and relaxation that existed within their relationship. Never ones to miss a photo opportunity, however, they set up this picture. Once again, everyone is engaged in an activity. Young Max had been taught how to fish by this time and had his own line well out into the current coming off the small waterfall. Ida was likewise fishing from shore and Frank from his canoe. Ernie was splitting firewood. And what of Bertha (at far left)? Looking closely one can see that this fearless woman – the woman who had not been afraid to bring her three-month-old child into this wilderness just a few years earlier – has a snake on the end of a stick. And while the eastern Massasauga rattlesnake was common in the delta region, this may have been the less dangerous, non-venomous, eastern hognose snake; photo dated 1918.

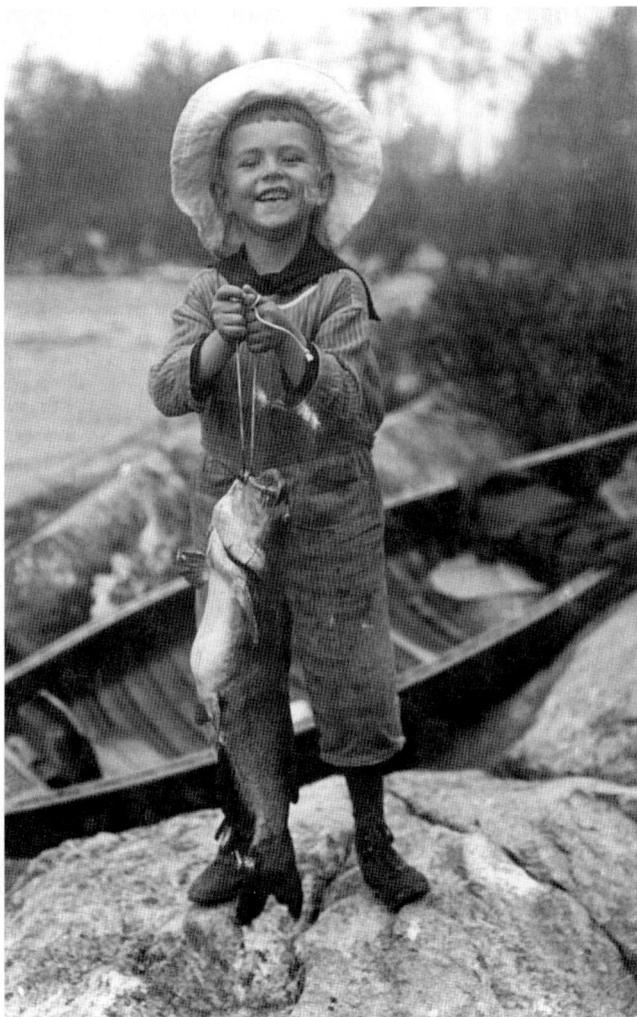

Frank's photo, RB-FF.24

Max Sherman, age six, 1919. Having been taught canoeing, camping, wilderness and fishing skills from infancy, there is no reason to doubt that the beaming smile on Max's face reflects the fact that he caught this catfish by himself.

PART FIVE

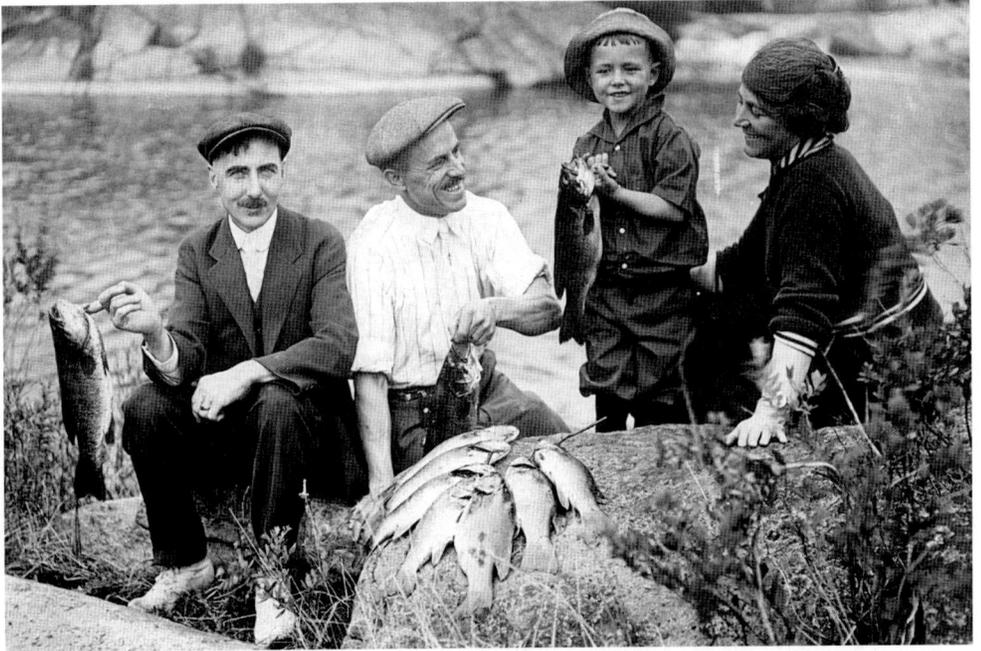

With his proud parents looking on, seven-year-old Max holds up his catch. Meanwhile, Uncle Ernie (at left), dressed for the activity in a three-piece suit and tie, sports a walleye on the end of his index finger, photo dated 1920.

The Final Expeditions, 1920–27

I used to think it was a major tragedy if anyone went through life never having owned a canoe. Now I believe it's only a minor tragedy.
– Bill Mason, *Path of the Paddle*

I t was becoming increasingly disheartening for the Rushbrooks and Shermans to make their annual trips to French River Village. While a few residents had stayed on following the closure of the Ontario Lumber Company mill in 1912–13, everyone knew the "writing was on the wall." Our eager explorers had enjoyed some wonderful experiences along the French and Pickerel rivers, had made some lasting friendships in the community and were, no doubt, saddened that most of these good folks, out of necessity, had been forced to leave the homes and the community they had loved for many years.

The last five or six trips during the period 1920–27 did not seem to reflect the same character and colour that had flavoured the earlier adventures. Ernie's wife, Alma, had not been able to accompany him on more than one trip. Their son, Gordon, while able to travel along on several of the 1926–27 trips generally presents the picture of a young man who was sickly and simply not enjoying himself in the same way his cousin, Max, had been doing for numerous years. Poor young Gordon suffered from extremely bad vision from a very early age, an infirmity that rendered him extremely timid and somewhat physically

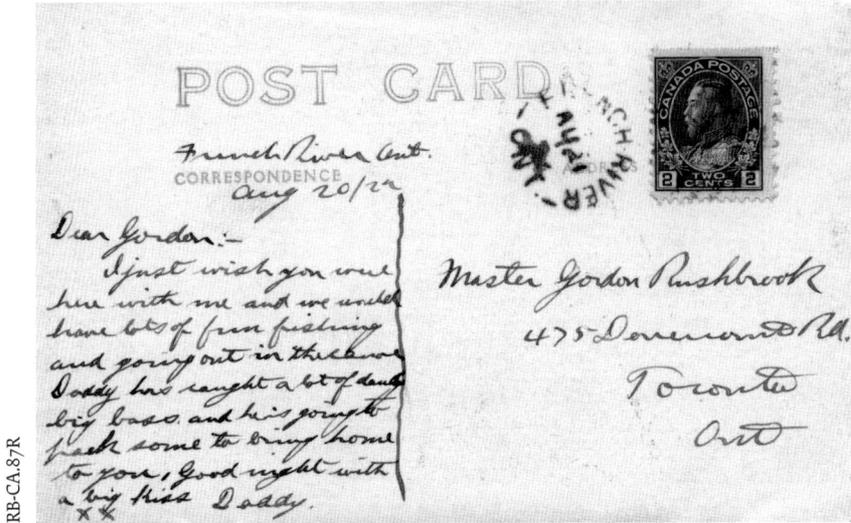

Ernie's card written to his son, Gordon, August 20, 1922.

restricted for the rest of his life. The strain of Gordon's disability and
the boy's lack of enjoyment shows on Ernie's face in most of the photos
from this period.[1] Ida does not seem to have been on more than one
trip after 1920 and Bertha's last trip was likely 1924–25. But where one
door closes, another opens. Both Ernie and Frank were very busy with
their chiropractic practices. Ernie and Alma's family grew as two more
children were born, Audrey (in 1920) and Ruth (in 1922), sisters for
Gordon. And while summer trips may not have involved the type of
wilderness adventures that had been experienced in the past, both
families seem to have begun leaning toward different places for holi-
days and different styles of relaxation.

Back in French River Village, Dean Udy, one of the mainstay charac-
ters of the community, decided to call it quits in 1922. The federal gov-
ernment had shut down *his* post office, sounding a further death knell
across the bleak, rocky shoreline that had once been a thriving, vital,
happy place. Dean packed his family, his belongings and his memories
and paddled upstream to Pickerel Landing. Even tourism was drying up.
As each year passed fewer and fewer people, goods and services were
available at the village. The booming hotel and lodge movement that
paralleled the CNR and CPR rail lines further east and north of the delta
had much more to offer to the seasonal anglers, hunters and canoeists

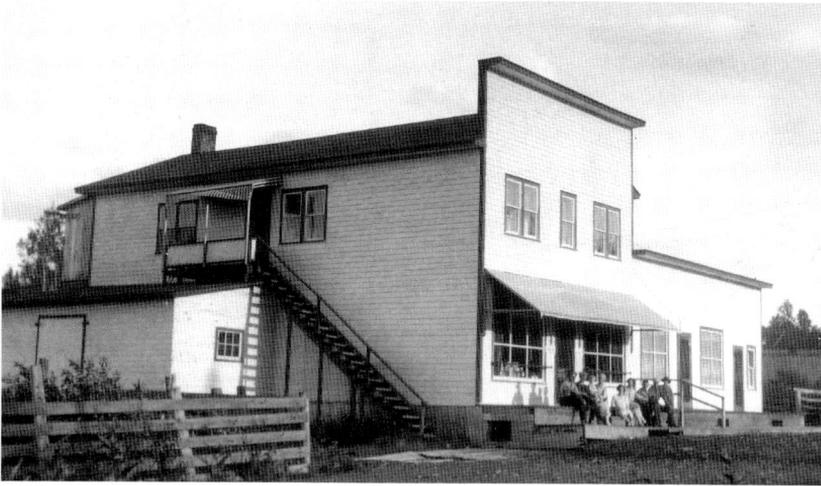

Timer photo, 1927. RB-CB.25

When he finally moved from French River Village in 1922, Dean Udy opened this general store at Pickerel Landing Village. The building also acted as a community post office where Dean served the needs of both local residents and tourists in his capacity of postmaster until the time of his death in 1930.

who were coming to expect a little more comfort, a little more pampering. Fewer people seemed to be willing to expend the amount of effort that Ernie, Ida, Bertha and Frank had thrown into their early excursions in French River country. The last resident of French River Village, a part-time lighthouse keeper, left the delta in 1934.[2]

Spanning only an eighteen-year period from 1910 to 1927, the photographic register of French River Village, including most of the lower French River and delta region that the Rushbrooks and Shermans had been able to compile, remains an incomparable historical record. With a special lightness, and often humourous approach to their photography, this happy family of adventurers succeeded in documenting their travels with an eye and an attitude few professional photographers of the time would have considered. That fact certainly gives their art – and the images they captured – a special place in Canadian history.

As we approach the 400th anniversary of Étienne Brûlé's first trip down the French River in 1610, it is refreshing to realize that thousands of modern canoeists, adventurers and photographers are rediscovering the French River each year and finding delight in the challenges this historic waterway continues to offer. Ernie Rushbrook would have been

A CPR telegraph receipt, August 22, 1927, for a message sent by Ernie from Toronto to Pickerel [Landing Village]. No doubt the recipient was Dean Udy, and the content of the "wire" was perhaps to notify him of the arrival time or supplies that would be required for the forthcoming trip.

An invoice from Dean Udy's general store, August 27, 1927, billed to Ernie Rushbrook. Note the typographical error concerning the word "Pickeral" as opposed to the correct spelling "Pickerel." Dean's notation "Pd, DU" appears inverted at the bottom of the invoice.

proud of the perseverance, the determination and the drive that his youngest daughter, Ruth Beard, has demonstrated in her careful preservation of such a significant chapter of our national heritage. The pictorial treasures that Ernie, Ida, Bertha and Frank wrestled from the French River will live on, not only in the eyes of those who have viewed their work, but also with the selfless invitation to enter their lives extended by those adventurers – even if only momentarily.

RB-CT.37

*Left to right: Bertha, Frank and Max. The Shermans may have done this trip
without Ernie and Ida. At age 45, and beginning to exhibit some grey hair, this
was perhaps the last French River trip Bertha would make. And while there is
much evidence to indicate that she and her family continued to do much more
travelling together, no other photos later than this 1924–25 shot picture her on a
wilderness camping trip. Frank had invested in a new, larger tent, complete with
bug net, for this expedition. The fact that they also had a folding table and three
chairs suggests they may have rented a larger craft or that Max or Frank may
have gone "solo" in a second canoe in order to carry the extra gear. Typical of
Frank's photographic method, this timer photo poses everyone with mouth wide
open and watermelon in hand.*

Whether the exposure setting was intentional or accidental, this shot of Ernie's is wonderfully composed and almost in silhouette style. Lining a heavy canoe over-flowing with gear would present a challenge in this fast set of rapids. It appears that several folding chairs may have been taken on this trip. With Frank now at age 51, and Ernie 48 years of age, the two men may have opted for a few more "creature comforts" on some of their final French River trips. This is one of the best shots that clearly illustrates the eight-foot-long, doubled ended paddle style that both Ernie and Frank had taken on all their trips since 1912. From left to right: Ernie, Gordon and Max, 1926.

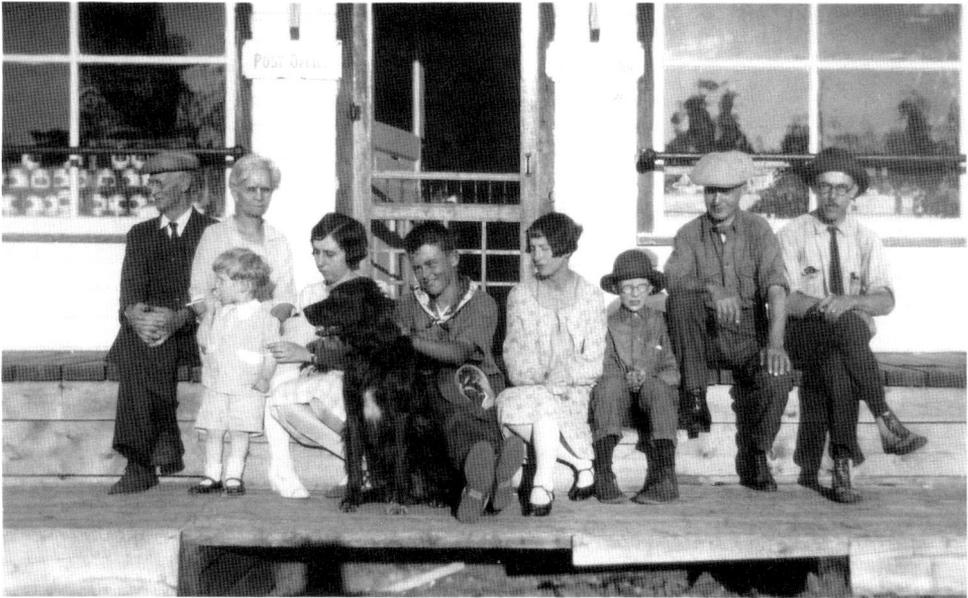

With no evidence of Ida or Bertha on this 1927 trip, this photo on the porch of Udy's general store at Pickerel Landing Village includes Dean Udy and his wife (at far left), Frank, Ernie and young Gordon (at the right end) and Max (centre) with the dog. The two young ladies and the boy are unknown.

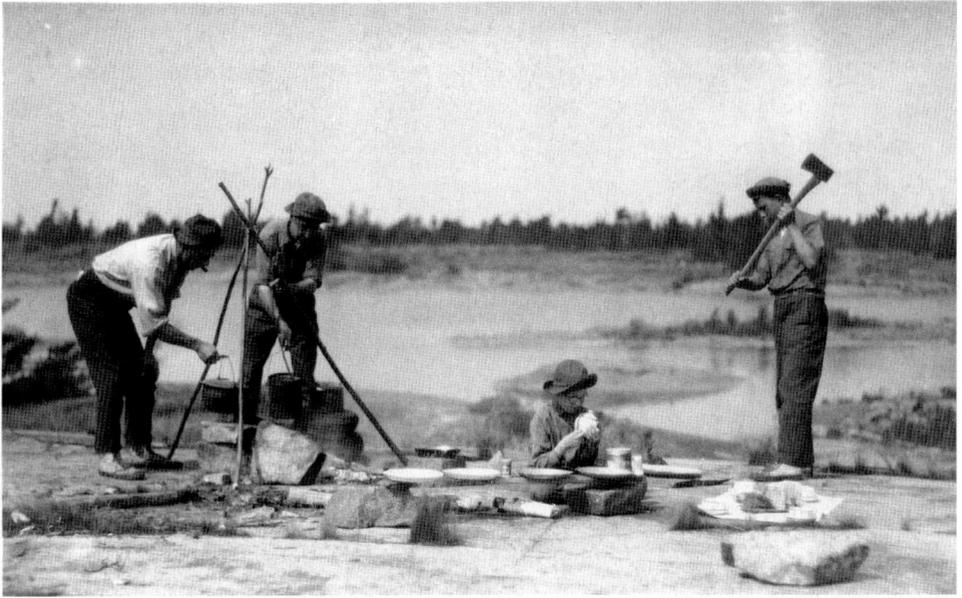

RB-SL.5

A shore lunch, 1927. From left to right: Frank, Ernie, Gordon and Max.

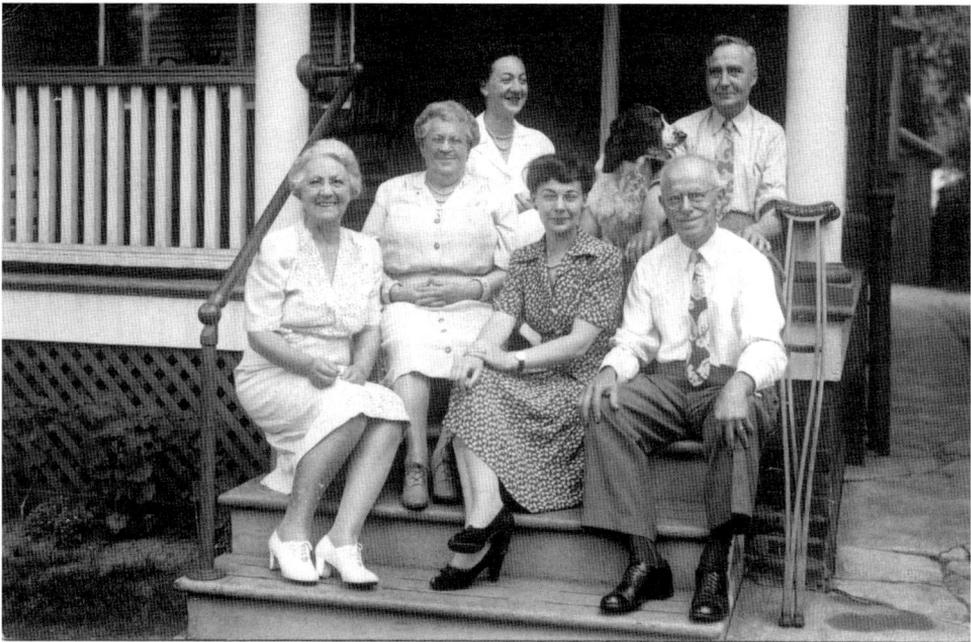

Toronto 1950. Top row, left to right: Ruth (Beard) Rushbrook, dog Rex, and Ernie;
Bottom row, left to right: Bertha, Alma Rushbrook (Ernie's wife), Audrey
Rushbrook and Frank. While generally known for his good health, Frank, now
at age 75, was using crutches for a short-term injury.

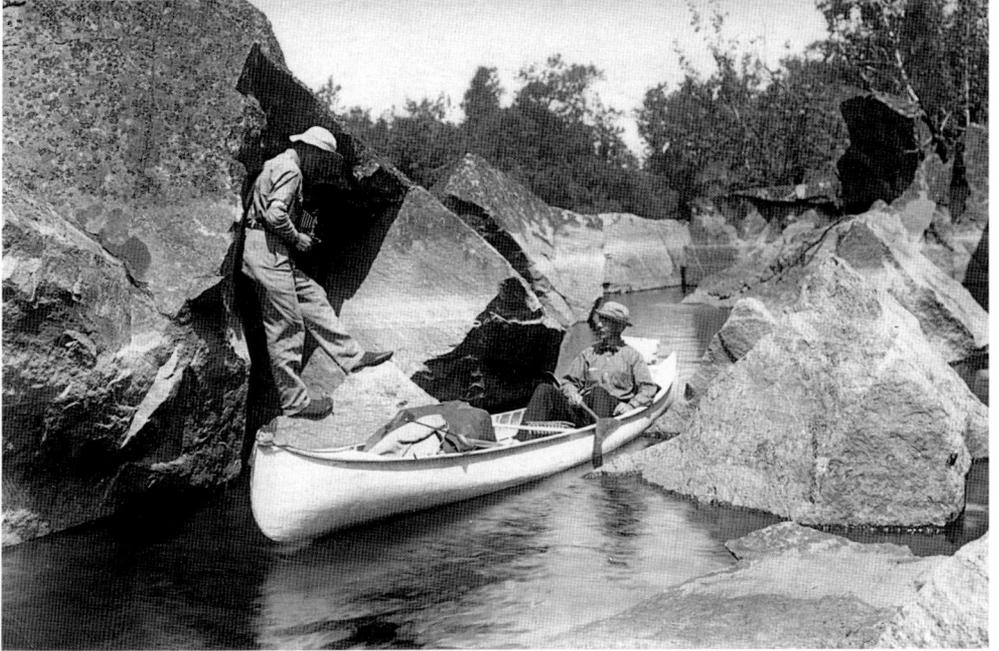

Epilogue
Following in Their Wake

*Canada consists of 3,500,523 square miles, mostly landscape. It is apparently
intended for the home of broad-minded people.*
– Algomaxim[1]

T he adventures of the Rushbrook and Sherman families at
French River Village, and along many areas of the lower French
River and delta region during the second and third decades of
the twentieth century, may inspire modern canoeists and explorers to
follow their footsteps. The French River is still there. The village is not.
The rocks, the tributaries feeding the great river, the flora and fauna are
still there. The horizon, however, has been modified. Almost all of the
old growth trees have been felled, but the "new" crop is now close to
one hundred years old. A few dams have been constructed and a few of
the rapids (especially the Dulles Rapids) have been blasted in recent
years to assist with flood control, so water levels may have changed. But
with a measure of persistence, it may be possible to locate many of the
areas that have been pictured in this book.

The entire French River region, from Lake Nipissing to Georgian
Bay, is rife with history. Simply hundreds of abandoned buildings, early
1900s cottages, old docks and other historic edifices dot the shorelines,
back roads and bush trails that, for the most part, are still accessible
with an average four-wheel-drive automobile. Scores of rivers, lakes,

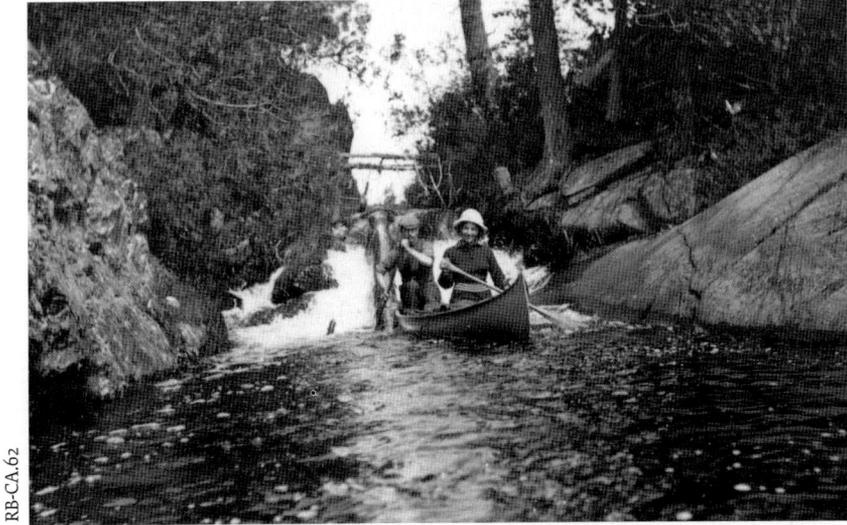

RB-CA.62

With Bertha looking just a little too relaxed, it is doubtful that she and Frank actually ran this narrow, log-congested rapid. A close look at where Frank has his paddle reveals that he is holding the canoe in place, no doubt while Ernie clicks this set-up shot. Somewhere on a French River tributary, 1912.

breath-taking vistas from elevated ground and a wonderful series of provincial parks abound throughout the area. Photographic opportunities are endless.

An infrastructure that favours tourism is also well embedded throughout French River country. Tourist and travel information booths, outfitters, canoe and kayak rentals, marinas, campgrounds, accommodation and restaurant facilities are plentiful. A network of charming small communities that offer automotive services, hardware and grocery stores, live bait, medical and pharmacy services and more, are easily accessed from all the main highways and county roads running through the area. Many tour operators exist along the French, often located at one of the modern or historic lodges. River cruises from two to five hours, some including dinner and a theatre presentation, are available. If all of this sounds too busy, it is not. The opportunities to canoe throughout the French and adjoining Pickerel River system, and the countless tributaries and smaller streams that merge with them, are unending. For those with the experience, and with the proper vessel, equipment and navigation charts, the 30,000 islands that

placidly rise in the blue waters of Georgian Bay offer still further oppor-
tunities for exploration.

At the time of writing, cellular phone service in the region was lim-
ited. For those who require or consider contact with the outside world
an essential issue, a satellite phone would no doubt be the only means
of communication possible when leaving the main trails or the most-
travelled river channels. Departure from any major marina or provincial
park office can be registered at most of those locations, and filing a
detailed trip plan with departure date, route, description of your craft
or vehicle, the number and names of persons in your party and return
date may be a wise decision.

Camping, canoeing, power boating, hiking, fishing, hunting, pro-
fessional guides, nature tours, birdwatching and other information
services are readily accessed throughout the region. Fishing and hunt-
ing licences and permits for citizens of Ontario and non-residents are
mandatory and readily available at many locations. With regard to fish-
ing, limits and "slot-size" regulations generally apply but may vary from
year to year and from species to species. Many specialized services are
available in the region including wheelchair accessibility and senior's
facilities and discount information. Contact with a lodge, motel or
tourism association in the area, or browsing through the abundant
number of Web sites for the French River region may be useful.

Within the relatively small Canadian population of 33 million, it is
estimated that one person in fifteen is a canoeist. Close to one and one
half million canoes and kayaks traverse our waterways annually. And as
Canadian canoeing icon, Bill Mason, put it in his book *Path of the Paddle*,
"in Canada, you can put a canoe into the water in any major city and
paddle to the Atlantic, the Pacific, the Arctic, or the Gulf of Mexico."

Travelling by road to French River country is not complicated.
From Toronto, a series of excellent freeways will see the traveller most
of the way to the intended destination. The trip from Toronto to the
location on Highway 69 where the road crosses the French River gorge
is 315 kilometres and can typically be accomplished in three-and-a half
to four hours. At the half-way point (if travelling north from Toronto)
when crossing the Severn River bridge, the traveller will appear to be
entering a different world. A dramatic change in the landscape will

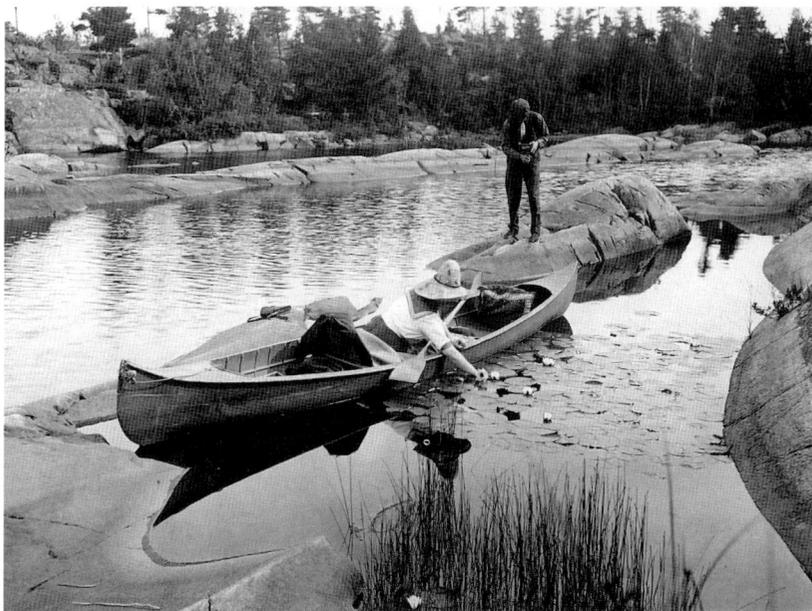

RB-CP.2

An idyllic afternoon.

greet the eyes. The rugged beauty of the rocky Canadian Shield and a significant change in vegetation is markedly noticeable.

In 1986, the French River became the first waterway in this country to be designated by the Government of Canada as a Canadian Heritage River. By 1989 the corridor that contains the entire shoreline of the river from east to west, was established as a Provincial Park. The management of this park is somewhat unique, compared to other provincial and national parks in Canada, in that French River Provincial Park is a waterway park. Care and management of the area gives consideration to the river as a navigation highway, but also views the recreational, historical and natural significance of the river and of the First Nations lands through which approximately twenty-five per cent of the river flows. A stop at the new French River Visitors Centre, which opened in July 2006, and is located just south of the Highway 69 bridge that crosses the river, will prove useful and informative.

In planning a trip to French River country, the following publications may prove extremely useful. They are listed in the order of importance that the author would suggest. Details as to the publishers of these items will be found in the bibliography.

Ontario Parks French River Map (2006).

Topographical maps (for the region) available in 1:50,000 scale from National Resources Canada, Mapping Services Branch

French River: Canoeing the River of the Stick-Wavers by Toni Harting. (Outstanding large-scale maps of specific areas)

Killarney and the French River by Kevin Callan

The French and Pickerel Rivers: Their History and Their People by William A. Campbell. (Out of print but available through the Ontario Public Library inter-library loan program)

Ghosts of the Bay: A Guide to the History of Georgian Bay by Russell Floren and Andrea Gutsche

The Canoe in Canadian Cultures edited by John Jennings *et al* (especially Chapter 13, "Historic Canoe Routes of the French River")

Paddle Your Own Canoe by Gary & Joanie McGuffin (one of the finest canoe-skills publications available)

Path of the Paddle by Bill Mason (*the* classic work on the art of canoeing)

Up the Creek: A Paddler's Guide to Ontario by Kevin Callan

Northeastern Georgian Bay And Its People by William A. Campbell

And, as a visual guide to locating and matching the Rushbrook-Sherman photographs with the way the river presents itself today, the book you are holding in your hands may assist with your own discovery of this remarkable waterway – the French River.

Notes

INTRODUCTION

1. Postcard communication from Ernest Rushbrook to his mother in Toronto, August 8, 1915. RB-FF.82R.

2. The photographs and stories related in this work represent perhaps five per cent of the total number of pictures, documents and historical collections owned by Mrs. Ruth Beard. With the time and circumstances available, it is hoped that more of these Canadian treasures will eventually appear, if not in book format, then in the care of persons or institutions that will preserve them for the edification of future generations.

3. *Rushbrook Parish Registers, 1567–1850*; Rushbrook family documents and genealogy lists (private collections); birth, marriage and obituary notices (assorted Toronto newspapers, undated); http://www.genforum.geneal-ogy.com/rushbrook, accessed on Jan. 2, 2007.

4. Donald Jones, "The Richest Man in Toronto's Past," *Toronto Star,* April 9, 1994. Taken from http://www.torontotourism.com/DistilleryHistoricDistrict; and http://www.toronto.com/hotels, accessed on Jan. 2, 2007. The Gooderham dynasty is a fascinating chapter of Canadian history. George Gooderham, a distant cousin of Eliza Rushbrook, had, at the time of his death in 1905, a personal fortune of some $25 million, and was considered to be not only the wealthiest man in Toronto, but the wealthiest man in the province. While much of his service to the City of Toronto went unseen and was reg-istered strictly as "anonymous," this generous benefactor provided funds to simply dozens of worthy causes across the city. Among the legacies left by George Gooderham that Torontonians, and visitors to the city alike, may observe and enjoy, are some of the still surviving architecture that he com-missioned. Included among them: the Flatiron Building (1892), at the cor-ners of Front and Wellington at Church Street, originally built to house the Gooderham and Worts Distillery head office; his personal family mansion "Waveney" (1893), one of the most impressive Victorian mansions in Toronto, located at the corner of Bloor and St. George streets; the King

Edward Hotel (1903), with a historical who's who guest book that, among many others, includes Rudyard Kipling, Mark Twain and The Beatles.

5. A numbering system for the photographs used in this publication was devised by the author for the purpose of easily locating specific items. Where possible, each picture or illustration will bear an identity number composed of letters and numbers that relate to the specific collection from which the image was obtained. Researchers who wish further information concerning particular photographs may use the corresponding identity number with any such request.

PART ONE: DEVELOPING THE CRAFT

1. Canadian artist, Tom Thomson (1877–1917), has been praised as one of the finest landscape artists in this country's history. His innovative style and his association with – and influence upon – fellow artists, among whom were notably the "Group of Seven," is a significant chapter in the national record. And while Ernie, Ida, Bertha and Frank may be considered "artists" of their time, using the medium of the camera as opposed to paint and canvas, there is one particular comparison between Tom Thomson and Ernest Rushbrook that highlights interesting similarities too coincidental to ignore. Both men were born in Ontario, with just one year separating them: Thomson in 1877, Rushbrook in 1878. Each man came from a large family: Thomson with nine siblings, Rushbrook with twelve. Both were musically inclined and participated in dramatic presentations in their formative years. They both had an abiding love and respect for the beauty of the Canadian wilderness. Thomson and Rushbrook each had a passion for Great Lakes ships and canoeing. Tom Thomson hiked frequently around Georgian Bay; Ernie Rushbrook explored the bay's Bustard Islands and French River delta. Each man was a devoted angler and enjoyed the relaxation and meditative opportunities that fishing and canoeing afforded them. Thomson was an avid photographer. His 1912 canoe trip into Algonquin Park saw him shoot 14 rolls of film, sadly only two of them surviving since his canoe capsized on the last day of his trip sending twelve rolls to the bottom of the lake. Rushbrook's photography stands on its own in this publication. One of Tom's surviving photographs of fish and a net fanned out in an artist manner on a rock is almost identical to several of Ernie's photos that also display fish and a net spread out symmetrically on a rock. Both men fought to overcome serious physical handicaps in their

young adulthood: Tom wrestled with a lung ailment, a painful "fallen arch" syndrome and a foot injury brought on from the combat of football; Ernie struggled with an injury incurred during a bobsled accident that left him, for several years, with a limp and partial paralysis. Both men appear to have had the same stature and shared similar facial features. Each man, in his early twenties, apprenticed as a machinist. They both lived and worked in Toronto during the first two decades of the twentieth century. Both men exhibited a spirit of generosity and compassion for others. Thomson, while he could ill afford it, was known to have bought clothing for several people who seemed destitute. Rushbrook's compassion as a young chiropractor in 1910 was frequently demonstrated when he paid his own train travel costs from Toronto to Newmarket to treat several patients who could simply not afford to travel to his office. While there is no record that the two men may ever have met, these similar features provide an interesting kindred bond between them. Sources: www.tomthomson.org; Joan Murray, *Tom Thomson: The Last Spring* (Toronto: Dundurn Press, 1994); Sherrill E. Grace, *Inventing Tom Thomson: From Biographical Fiction to Fictional Autobiographies and Reproductions* (Montreal: McGill-Queen's University Press, 2004).

2. Although photography had stepped upon the world stage in the late 1830s and 1840s, it could still rightly be called a "new science" up through the 1880s and 1890s. It was not until then – and following hard on the heels of three or four decades of wild experimentation – that the art form began to escape from the collodion clutches of the serious-minded professionals and gain an ever-growing popularity among a younger generation who were beginning to see the opportunity for photographic fun in leisure-time activity. Information from http://www.leonardo-davinci.org/monalisa.php, accessed on Feb. 23, 2007.

3. David Neel, *The Great Canoes* (Vancouver, BC: Douglas & McIntyre Ltd., 1995) 26.

4. Walter Rushbrook letter to Mr. Hume, March 25, 1950. Walter Rushbrook, who had been born in Wellington Square (now Burlington, Ontario) in 1868, was perhaps one of the finest historians in his family. Author of numerous booklets, lengthy essays and personal letters that have survived thanks to the saving hands of his niece, Ruth Beard, Walter is the "stuff" of which Canadian legends are made. His escapades on Great Lakes ships during the 1890s, his time among the Pacific northwest peoples, his photographs and Haida artifacts collection, and his three-decade-long voyages on

the *Northern Cross* – a motor launch that plied the rivers and ocean inlets all along the British Columbia, Queen Charlotte and Vancouver island coast- lines – are rife with adventure and dramatic colour. In 1943, as war hysteria paralyzed the clear thinking abilities of many Canadian officials, Walter, at age seventy-five, was briefly taken into the service of the Royal Canadian Navy as a consultant who was apparently viewed as the "one man" who was in the best position to provide intelligence about locales along Canada's west coast where Japanese submarines or invasion forces might be most likely to stage an attack.

5. A close look at this structure reflects that it was not a design typical in pre- confederation Ontario. More akin to the combination house and barn struc- tures of Switzerland, Austria and Germany, it features a barn on the lower level and a squared timber dwelling above. The presence of a brick chimney would indicate that it was an abode inhabited by humans. It is also built on the side of a hill, no doubt a main entry door existing on the high side of the building. With the long shadow of the man being cast on the stone wall, it would appear to have been late afternoon. Significant effort would no doubt have been required to make the trip home before dark.

6. From Wayne Kelly, *The Great Storm of 1913* (unpublished manuscript, 1993), and from http://www.shipwreckwexford.ca, The Great Storm of November 7–10, 1913, was considered to be one of the most deadly and destructive storms of Great Lakes history. The storm killed more than 250 people, sank 19 ships and badly damaged 19 more. With blinding snow squalls, 145 km/h winds and waves running at 11 metres, the four-day ordeal for those caught on the open water must have been beyond belief. The *Wexford* foundered 15 kilometres offshore from St. Joseph, a community halfway between the vil- lages of Grand Bend and Bayfield. She was found by divers in August 2000 lying at a depth of 25 metres. She had a fascinating history, having been built in England in 1883 and plying the seas from Europe to Argentina, returning cargoes of sugar, bananas, raw rubber, tea and tung oil to the British mercan- tile until she was sold to interests who equipped her for Great Lakes com- merce in 1904, bringing her to Collingwood for a total refit.

7. It is important to relate a fact concerning the photographic process that perhaps some non-photographers may not appreciate. As a long-time pho- tojournalist, it has been my unbroken belief – a belief shared by many pro- fessional photographers – that we must live by the "one in a hundred" rule

of thumb. That is, if you are able to capture one outstanding, publication-quality picture out of a hundred shots, you have done well. Fortunately, with the advent of digital photography, it is now possible to "delete" the unwanted, inferior-quality photos with the click of a button, thus saving photographers a large expense that has traditionally been spent on commercial photofinishing. A story related to me some years ago, when one of my books was being considered for the "cover story" of a national magazine, makes an interesting point relative to the photographs that are destined to survive throughout history, and those that do not. During the mid-1980s, one of Canada's top photographers (an acquaintance who can remain unnamed) was hired by *National Geographic* to shoot images of the Great Lakes. Few budget parameters were given. Helicopters, fixed-wing planes, boats and trucks were used to position the photographer for his work; a project that took many months. Twenty-four thousand colour transparencies were taken. *National Geographic* loved the work. But they printed only *six* of the photos with the accompanying article. How well this highlights the fact that if professional photographers (and editors) in our time "waste" such a large proportion of photographs in order to get just the right one, we can only imagine the hundreds of images that Ernie, Ida, Bertha and Frank may have captured, only to edit them to the trash can.

8. Having been raised in the Essex and Kent County areas of Ontario, Frank would no doubt have been familiar with Windsor and her border city relationship with Detroit. Travel across the border was a much simpler matter one hundred years ago than it is today. Perhaps Frank's early memories or experiences in Detroit were what prompted him to not only open his first chiropractic practice there in June of 1910, but to settle there with his family for the rest of his life.

9. A popular recreation spot for Torontonians for well over 100 years now, this small inland lake that feeds directly into Lake Ontario was – according to local legend – apparently named following the accidental drowning of a small group of British Grenadiers who tried to cross the pond in pursuit of a band of American soldiers during a February storm in the War of 1812. However, this account does not stand up to scrutiny. The 1813 Battle of York occurred in late April when there was no ice on the pond and all casualties were documented, none of whom disappeared into the pond. Another account of the accident suggests the Grenadiers, who were probably stationed at Fort York, drowned when the ice beneath them gave way while

they were fishing or hunting at the pond as guests of John Howard, owner of the property at the the time. He bequeathed the land to the City of Toronto for a park, today's High Park. From http://www.torontoparks.ca, accessed on Jan. 12, 2007.

10. The term "Sooner" was originally used in a derogatory sense to refer to the group of settlers who unlawfully claimed lands in what eventually became the State of Oklahoma. Staking their claim to land prior to 1889 when the Oklahoma territory was opened under the Indian Appropriation Act of that year, land was supposed to have been lawfully claimed by registering and participating in one of the now famous "land runs" of the time. According to the Oklahoma Tourism Board, the term "Sooner" eventually "lost its derogatory connotations and began to represent the irrepressible, hardy pioneer spirit of Oklahoma." Taken from http://www.oklahoma.gov, accessed on Jan. 2, 2007.

11. *The Focal Encyclopedia of Photography* (New York: The Focal Press Ltd. McGraw-Hill Book Company, 1969). The Number 3A Folding Pocket Kodak cameras used by the Rushbrook-Sherman team had been manufactured by Eastman Kodak of Rochester, New York, and introduced to the consumer in 1903. Considered historically to have been one of the most popular "postcard-size" cameras ever made, it was eventually produced in six different models and as many as twenty-seven different lens and shutter combinations until its demise in 1934. Known also as a "folding bellows" camera, it featured an interior designed to accept rolls of four or six exposure film in an 83 x 140 mm format, although an interchangeable back that would accommodate glass plates was available. The roll film, however, appears to have been the more popular choice among amateur photographers and was considered a very significant factor in the early 1900s, as the large negatives could be printed on postcard-size photo paper with little or no enlargement neces-sary. The list price for this camera in 1903 was $20.00.

12. Author's personal collection. The French River postcards created by Ernie and Frank were not the first of that format and subject to appear. Commercial photographers J.B. Miller from Parry Sound, Ontario, and J.W. Bald are known to have produced several thousand postcards featuring Canadian and wilderness scenes, and a few of these focused on French River Village c.1900–1905. Bald's picture postcards were printed in bulk in England and distributed around the world.

PART TWO: LAYING ON HANDS

1. George Rushbrook's obituary notice, August 31, 1907, Rushbrook family
papers. George Rushbrook had spent time in the "service of the Queen" for
a short time after arriving in Canada. He had joined the Company of the
10th Royals (later the Royal Grenadiers) on March 14, 1862, and had attained
to the rank of first sergeant on February 2, 1863. At the time of his death,
he was considered to have been the last surviving member of his company.
George had owned and operated a tailor shop on Toronto's Bloor Street
West up to the time of his retirement in 1902.

2. The more popular shutter timers of the early 1900s had employed lengths
of rubber tubing with an air bulb attached at one end. When the bulb was
depressed by the hand of the photographer, a mechanism fitted to the
camera at the opposite end of the tubing would depress the shutter lever
and take an exposure. Devices of this type have continued in use by some
photographers up to the present day. A 15-metre length of tubing is about
as long as can be operated with the squeeze bulb method. Since many of
the timer shots taken by the Rushbrook-Sherman photographers far
exceeded 15 metres, it is reasonable to conclude that Ernie's clockwork
timer inventions were employed.

3. Dr. Joseph E. Maynard, *Healing Hands: The Official Biography of the Palmer Family,
the Discovers and Developers of Chiropractic* (Mobile, AL: Jonorm Publishers,
1959). The early history of chiropractic is rife with drama, scandal and pris-
matic colour. D.D. Palmer was not beyond creating controversy and conster-
nation. In a letter dated May 4, 1911, he wrote, "We must have a religious
head, one who is the founder as did Christ, Mohamed, Joseph Smith
[Mormonism], Mrs. Eddy [Christian Science], Martin Luther and others who
have founded religions. I am the fountain head. I am the founder of chiro-
practic in its science, in its art, in its philosophy and in its religious phase."
The word "chiropractic" comes from an amalgam of Greek words meaning
"done by hand." The practice was not really new with Palmer. The preva-
lence of various methods of physical manipulation of the spine is found in
such diverse cultures as ancient Egypt, Greece, China, Africa and among
Amerindian tribes. Spinal manipulation and bone-setting in early 19th cen-
tury England was widely used by medical professionals. The horrors of the
American Civil War (1861–65) provided the unfortunate "school" where
medical doctors were confronted with countless bodies torn, wracked and

dismembered in that violent conflict, a situation that resulted in many med-
ical discoveries and techniques, including spinal adjustment, being added to
the canon of remedies that came to popular use.

4. *Chiropractic History.* Centennial Issue, Vol. 15, no. 2, December 1995, 60-61.
The year 1995 was a milestone for the chiropractic profession. It marked the
150th anniversary of the birth of D.D. Palmer (1845), the 100th year of com-
memoration of the beginning of chiropractic (1895), and the 50th anniver-
sary of the Canadian Memorial Chiropractic College located in Toronto
(1945). Canada Post remembered the multi-celebration year by issuing
three new stamps, one for each of the three noteworthy events.

5. Russell W. Gibbons. "D.D. Palmer: The Origins of the Palmer School and the
Itinerant Schoolman, 1897–1913," in *Chiropractic History*, Vol. 18, no. 2,
December 1998, 40-51. D.D. Palmer had moved to Medford, Oklahoma, to
join his brother, Tom, who had been publishing a newspaper in that com-
munity for several years. Moving shortly from Medford to Oklahoma City,
D.D. helped establish three chiropractic schools between 1906–08: Carver-
Denny College, Palmer-Gregory College and the D.D. Palmer Chiropractic
College. The Palmer college was sold and renamed Oklahoma Chiropractic
Institute in November, 1908, when D.D.'s "itchy foot" motivated him to
move on to California. That latter school was the facility from which Ernie
and Frank had graduated. Their original diplomas, part of the Rushbrook
documents collection, also indicate that each man had been elevated within
the ranks of the small college; Ernie is shown on the diplomas as serving in
the capacity of treasurer, while Frank is listed as the vice-president.

6. Modern chiropractic tables are divided into four main components: a head
rest that may tilt to various angles or be stationery, a cervical, a thoracic and
a lumbar section. The latter three sections may also be individually
adjustable or remain fixed in stationary position. An adjustable thoracic sec-
tion, as Ernie Rushbrook's home-made table offered, allowed the chiroprac-
tor the option to raise or lower the mid-section of the table to
accommodate a corpulent or pregnant patient by permitting the larger
anterior abdomen to be positioned below the rest of the body while in a
prone position hence allowing the overall length of the spine to be more
generally parallel to the floor. Many of today's chiropractic tables may also
include a horizontal elevation feature that allows for the varying heights of
numerous chiropractors who use the same table, or may be employed to

lower the patient closer to the floor thus allowing the practitioner to apply more of his/her own force and body weight in the fulfillment of a particular chiropractic manoeuvre. The author spent several years (1994–98) as a freelance consultant to a branch of the Canadian Chiropractic Association (CCA), instructing new chiropractic graduates in the use of radiological (x-ray) equipment, electro-therapy modalities, and demonstrating the use of newly-designed chiropractic tables. Under the wing of two Canadian manufacturers, he has also written several instruction manuals for the use and maintenance of chiropractic equipment and was short-term editor for a monthly newsletter published by the Canadian Chiropractic Equipment Division of the CCA.

PART THREE: INTO THE WILDERNESS, 1910–12

1. In the few instances where it is necessary to refer to time periods in excess of 2,000 years ago, this publication will use the designations B.C.E. and C.E. as opposed to BC and AD, following the lead of a growing number of English-language historians around the world. The abbreviations BC and AD stand for "before Christ" and *anno Domini* (in the year of our Lord), respectively. These designations are now considered somewhat offensive to the growing number of persons in English-language societies who do not profess Christian beliefs. In addition, they are factually incorrect. If the Bible is to be considered as the source and reason for the use of such terms, then the Bible should be examined with this in view. The title "Christ" (from Greek *Kristos* or its Hebrew equivalent *Mashiach* or "Messiah") means "Anointed One." According to Biblical references, Jesus of Nazareth did not have the appellative title of "Christ" applied to himself until the time of his water baptism. Since that event occurred when he was approximately thirty years of age (in the year 29 C.E.), the use of BC and AD is actually off by that amount of time. The use of C.E. (Common Era) and B.C.E. (Before the Common Era) are now customarily used by many scholars and historians. These designations are not only more appropriate, they are more correct. Among those preferring the use of BCE/CE is the prestigious American Anthropological Association founded in 1902.

2. Taken from http://www.canadianarcaeology.com, accessed on Jan. 22, 2007, and from http://www.civilization.ca, accessed on Nov. 22, 2006.

3. Many geological theories abound as to the timing and development of

these events. The succinct chronology presented in Toni Harting's fine work, *French River: Canoeing the River of the Stick-Wavers* (Erin ON: Boston Mills Press, 1996) 19-21, provides a description and time line that should satisfy the average layperson concerning the geological formation of the river and its environs.

4. *Ontario Parks French River Map*, published by the The Friends of the French River Heritage Park, Copper Cliff, ON, 2006.

5. As quoted in William A. Campbell, *Northeastern Georgian Bay and Its People* (Sudbury, ON: self-published, 1996).

6. Russell Floren, Andrea Gutsche. *Ghosts of the Bay: A Guide to the History of Georgian Bay* (Toronto: Lynx Images Inc., 2004) xx. A parallel point of interest involves the naming of a rock formation in the French River that is within a thirty minute hike from the new French River Visitor's Centre (opened in July 2006), located just south of the Highway 69 river bridge. Récollet Falls was apparently named in memory of six Récollet Order priests whose canoe capsized at that location about 1625. All on board drowned. Standing on a rock ledge just metres from the falls in November 2006, I marvelled at the power and volume of water racing over a shelf that does not appear to present more than a two-and-a-half metre drop. The deception has apparently caused the demise of numerous canoeists during the almost four centuries since the Récollet incident. A suction eddy (or whirlpool vortex, as some may call it) exists in several places at the base of the falls. While some bold canoeists and kayakers may believe they can "run" this obstacle – and perhaps some have succeeded – the very real danger of being drawn into the vortex should give pause for wiser consideration.

7. Toni Harting, *French River: Canoeing the River of the Stick-Wavers*, 15-16. Toni's understanding of the origin of the Ojibwa word for the French River is *Wemitigoozhi Ziibii*. "*Wemitigoozhi* means stick-waver and *Ziibii* means River. This peculiar name originates from the Native Peoples' first contact with French missionaries who were waving their crosses around while blessing the people. In time this name *Wemitigoozhi* was applied to all Frenchmen."

8. Herbert J. Cranston, *Huronia: The Cradle of Ontario's History* (Barrie, ON: Huronia Historic Sites and Tourist Association, 1950).

9. Marjorie Wilkins Campbell, *The Nor' Westers* (Toronto: Macmillan of Canada, 1974).

10. Peter Labor, "The Canot du Maître: Master of the Inland Seas." *The Canoe in Canadian Cultures.* Toronto: Natural Heritage/Natural History Inc., 1999; and from http://www.metisnation.org, accessed on Nov. 27, 2006. The *canot du maître* was often 10 to 12 metres in length, required paddle-power of 12 to 14 good men and had a load capacity of 4,500 kilograms. The *canot du nord,* a smaller design craft more suited to narrow, fast-flowing rivers, was typically 5 to 6 metres in length, required four to six paddlers and would haul a load of some 1,600 kilograms. An excellent example of a *canot du maître* was on display at the Royal Ontario Museum in Toronto at the time of writing.

11. Donald Honing, *Frontiers of Fortune: The Fur Trade* (New York: McGraw-Hill Book Company, 1967).

12. The great Chicago fire (October 8–10, 1871) killed 300 people. Over 90,000 city residents were suddenly homeless and the staggering sum (for the time) of $200 million property damage was assessed. By 1875, municipal officials boasted that most of their "Windy City" community had been rebuilt. Taken from http://www.chipublib.org/greatfire, accessed on Feb. 3, 2007.

13. Taken from http://www.thecanadianencyclopedia.com, accessed on Feb. 8, 2007, and from http://www.biographi.ca, accessed on Dec. 12, 2006.

14. John Macfie, *"Post Office Closure Marks End of Era."* North Star Publishing, Parry Sound, ON, June 30, 2004 and from http://www.parrysound.com, accessed on Dec. 13, 2006.

15. Thomas O. Bolger, Provincial Land Surveyor. Letter to the Commi-ssioner of Crown Lands, October 28, 1875.

16. William A. Campbell, *Northeastern Georgian Bay And Its People.*

17. John Macfie, as reported in William Campbell's *The French and Pickerel Rivers: Their History and Their People*, Sudbury, ON: self-published, 1992. A board foot was considered to be 1 foot x 1 foot x 1 inch (approximately 2.36 litres by volume) before drying, milling and planing.

18. Letter of incorporation, May 8, 1883, from the Bob Boudignon collection as published in William A. Campbell, *Northeastern Georgian Bay And Its People*.

19. Ron Brown, *Ghost Towns of Ontario*, Vol. 2 (Toronto: Cannonbooks, 1983).

20. Ron Brown, *Ghost Towns of Ontario*, Vol. 1 (Toronto: Cannonbooks, 1978).

21. Taken from http://www.collectionscanada.ca/trains, accessed on Nov. 30, 2006.

22. *Ontario Parks French River Map*, published by The Friends of the French River Heritage Park.

PART FOUR: DEATH OF THE VILLAGE, 1913–19

1. William A. Campbell, *The French and Pickerel Rivers: Their History and Their People*.

2. Ibid.

3. *La Mer Douce* or "Freshwater Sea" was the name Champlain had given to Georgian Bay in 1616. See Part Three.

4. Russell Floren and Andrea Gutsche., *Ghosts of the Bay: A Guide to the History of Georgian Bay* (Toronto: Lynx Images Inc., 2004).

5. Ron Brown, *Ghost Towns of Ontario*, Vol. 2.

6. Pickerel River (CNR) was located some 14 kilometres west of Pickerel Landing Village (CPR). Confusion as to the location of these two communities has been compounded by the fact that they have often been called by other names by the residents who have inhabited the area. Hence we find numerous publications that refer to Pickerel Village, Pickerel Landing, Pickerel Landing Village, Pickerel Station, Pickerel River, Pickerel (CNR), Pickerel (CPR), or just plain Pickerel. And in 1927, a typographical error on a batch of commercially-printed invoices for Dean Udy's store, called the community "Pickeral." Likewise, the designation "French River" has been a source of confusion for many history detectives. French River Village, the community that the Rushbrooks and Shermans frequently visited, has been located in as many as seven different places on contemporary maps that have tried to describe the delta village in recent years. To flummox this further, there is

still a community known as "French River" located at the convergence of the French River and Dry Pine Bay, just east of Highway 69. Then, there is the actual waterway of the French River. Since 1989, French River Provincial Park has existed and, as of January 1, 1999, with the wisdom extended by the provincial government, a regional municipality known as "French River" now encompasses the communities of Alban, Rutter, French River Station, Ouellette, Noëlville (formerly Cosby), Monetville (formerly Martland), Wolseley Bay and several smaller communities (now nothing short of ghost towns that have ceased to exist) spread across nine townships.

PART FIVE: THE FINAL EXPEDITIONS, 1920–27

1. Gordon Rushbrook, while having been a victim of rather poor health in his childhood, followed his father's footsteps in many ways. He graduated from the Canadian Memorial Chiropractic College in 1950 and was well-regarded by his patients and colleagues up to the time of his death in 1996 at age 78.

2. William A. Campbell, *Northeastern Georgian Bay And Its People.*

EPILOGUE

1. Algomaxims were philosophical phrases created by the Group of Seven during the 1920s. Taken from http://www.tomthomson.org/groupseven, accessed on Jan. 27, 2007.

Bibliography

Acorn, John and Ian Sheldon, *Bugs of Ontario*. Edmonton, AB: Lone Pine Publishing, 2003.

Any Day A Fish Day, Ottawa, ON: Department of Fisheries, 1937.

Atlas of Canada, Montreal, QC: Reader's Digest Association (Canada) Ltd., 1981.

Berglund, Berndt, *Wilderness Survival*. Toronto: Pagurian Press Limited, 1972.

Bice, Ralph, *Along the Trail with Ralph Bice in Algonquin Park*. Toronto: Natural Heritage Books, 1993, reprinted 2001.

Boyer, Dwight, *True Tales of the Great Lakes*. Dodd, New York: Mead & Company, 1971.

Bringhurst, Robert, *The Black Canoe: Bill Reid and the Spirit of Haida Gwaii*. Vancouver, BC: Douglas & McIntyre, 1991.

Brown, Ron, *Ghost Towns of Ontario*, Vol. 1. Toronto: Cannonbooks, 1978.

_____, *Ghost Towns of Ontario,* Vol. 2. Toronto: Cannonbooks, 1983.

Burns, Bob and Mike Burns, *Wilderness Navigation*. Seattle, WA: The Mountaineers Books, 2004.

Callan, Kevin, *Up the Creek: A Paddler's Guide to Ontario*. Erin, ON: The Boston Mills Press, 1996.

_____, *Killarney and the French River*. Erin, ON: The Boston Mills Press, 2006.

Campbell, Marjorie Wilkins, *The Nor' Westers*. Toronto: Macmillan of Canada, 1974.

Campbell, William A., *The French and Pickerel Rivers: Their History and Their People*. Sudbury, ON: self-published, 1992.

_____, *Northeastern Georgian Bay And Its People*. Sudbury, ON: self-published, 1996.

The Canadian Encyclopedia: Year 2000 Edition. Toronto: McClelland & Stewart Inc., 1999.

Canadian Fish Cook Book, Ottawa, ON: Department of Fisheries, 1959.

Choquette, Robert, *Ontario – An Informal History of the Land and Its People*. Toronto: Ontario Ministry of Education, 1984.

Cranston, Herbert J., *Huronia: The Cradle of Ontario's History*. Barrie, ON: Huronia Historic Sites and Tourist Association, 1950.

David, Jennifer (ed.), *Wind, Water, Rock and Sky: The Story of Cognashene, Georgian Bay*. Cognashene, ON: The Cognashene Book Corporation, 1997.

Denison, John, *Micklethwaite's Muskoka*. Toronto: Stoddart Publishing Co. Ltd., 1993.

Falconer, Melody, "Reuben R. Sallows: Moments Forever Frozen in Time." in
 Goderich *Signal-Star*, September 19, 1990.

Fischer, George; Harris, Mark, *Waterfalls of Ontario*. Toronto: Firefly Books, 2003.

Floren, Russell and Andrea Gutsche, *Ghosts of the Bay: A Guide to the History of
 Georgian Bay*. Toronto: Lynx Images Inc., 2004.

The Focal Encyclopedia of Photography. New York: The Focal Press Ltd., McGraw-
 Hill Book Company, 1969.

Gernsheim, Helmut, *A Concise History of Photography*. New York: Dover
 Publications, Inc., 1986.

Gibbons, Russel W. (ed.), "Chiropractic History" *The Archives and Journal of the
 Association for the History of Chiropractic*. Russel W. Gibbons, Editor.
 Assorted issues: December 1990, December 1993, June 1995,
 December 1995, December 1998.

Goldberg, Vicki, *The Power of Photography: How Photographs Changed Our Lives*.
 New York: Abbeville Press, 1991.

Gorski, Tim, "Chiropractic – Healthy Skepticism," in T*he Newsletter of The North
 Texas Skeptics*, Vol. 8, no. 4, 1994.

Grace, Sherrill, *Inventing Tom Thomson*. Kingston, ON: McGill-Queen's University
 Press, 2004.

Gratton, Vince, "Postcards From Our Past." Stratford *City Gazette*, September 15,
 2006.

Greenhill, Ralph and Andrew Birrell, *Canadian Photography 1839–1920*. Toronto:
 The Coach House Press, 1979.

_____, *Early Photography in Canada*. Toronto: Oxford University Press, 1965.

Guillet, Edwin C., *The Pioneer Farmer and Backwoodsman*. Toronto: University of
 Toronto Press, 1963.

Harting, Toni, *French River: Canoeing the River of the Stick-Wavers*. Erin, ON: The
 Boston Mills Press, 1996.

Henderson, Bob, *Every Trail Has a Story*. Toronto: Natural Heritage Books, 2005.

The History of Chiropractic. Waukee, IA: Kerkhoff Chiropractic Publications, 2001.

The History of Palmer Chiropractic. Davenport, IA: Palmer Foundation for
 Chiropractic History, 2005.

Honing, Donald, *Frontiers of Fortune: The Fur Trade*. New York: McGraw-Hill Book
 Company, 1967.

Howes, Clifton A., *Canadian Postage Stamps and Stationery*. Lawrence, MA:
 Quarterman Publications, Inc., 1974.

Insight on the Scriptures, Vol. 2. Brooklyn, NY: Watch Tower Bible and Tract
 Society of New York, Inc., 1988.

Jacobseon, Cliff, *The Basic Essentials of Map & Compass*. Merrillville, IN: ICS Books,
 Inc., 1988.

Jennings, John; Bruce W. Hodgins and Doreen Small, (eds.). *The Canoe in Canadian Cultures*. Toronto: Natural Heritage Books, 1999.

Jones, Donald, "The Richest Man in Toronto's Past." *Toronto Star*, April 9, 1994.

Kelly, Wayne. "Reuben Sallows – Artist With a Camera." Unpublished manuscript, 1992.

_____, "The Great Storm of 1913." Unpublished manuscript, 1993.

Kershaw, Linda, *Trees of Ontario*. Edmonton, AB: Lone Pine Publishing, 2001.

Lothrop, Eaton S. Jr., *A Century of Cameras*. Dobbs Ferry, NY: Morgan & Morgan, Inc., 1973.

MacGregor, Roy, *A Life in the Bush*. Toronto: Penguin Books Canada Ltd., 1999.

The Making of Canada: Ontario. Washington, DC: National Geographic Society, 1996.

Maynard, Joseph E., *Chiropractic Healing Hands: The Official Biography of the Palmer Family, the Discoverers and Developers of Chiropractic*. Mobile, AL: Jonorm Publishers, 1977.

Mason, Bill, *Path of the Paddle*. Toronto: Key Porter Books, 1984.

McGuffin, Gary & Joanie, *Paddle Your Own Canoe*. Erin, ON: Boston Mills Press, 1999.

Moodie, Susanna, *Roughing It in the Bush, or, Life in Canada*. London, UK: Richard Bentley Publishers, 1853.

Moore, J. Stuart, *Chiropractic in America: The History of a Medical Alternative*. Baltimore, MD: Johns Hopkins University Press, 1993.

Mosby's Pocket Dictionary of Medicine, Nursing & Allied Health. Philadelphia, PA: The C.V. Mosby Company, 1990.

Murray, Joan, *Tom Thomson: The Last Spring*. Toronto: Dundurn Press, 1994.

_____, *Tom Thomson: Design for a Canadian Hero*. Toronto: Dundurn Press, 1998.

Neel, David, *The Great Canoes*. Vancouver, BC: Douglas & McIntyre Ltd., 1995.

Newhall, Beaumont, *The History of Photography: From 1839 to the Present*. New York: The Museum of Modern Art, 1982.

Oklahoma Chiropractic Institute (prospectus). Oklahoma City, OK, 1908.

Ontario Parks French River Map. Copper Cliff, ON: The Friends of the French River Heritage Park, 2006.

Penson, S. and J. Rogers, *Guide Book & Atlas of Muskoka and Parry Sound Districts 1879*. Owen Sound, ON: Richardon, Bond & Wright, Ltd., 1972. (second offset edition)

Pollack, Peter, *The Picture History of Photography*. New York: Harry N. Abrams, Inc., 1977.

Raffan, James and Bert Horwood, (eds.) *Canexus: The Canoe in Canadian Culture*. Toronto: Betelgeuse Books, 1988.

Recreational Fishing Regulations Summary, 2005–2006. Ministry of Natural Resources. Queen's Printer for Ontario, 2005.

Saunders, Gary L., "River Craft." *Canadian Geographic*, November/December, 2003.

Savage, James, *Algonquin: An Illustrated Poem.* Toronto: Natural Heritage Books, 1993.

Seary, Victor, *A Postage Stamp History of Canada.* Toronto: McGraw-Hill Ryerson Ltd., 1972.

Sorensen, Scott, *Kipawa River Chronicles: Adventures in the North Woods.* Self-published, 1999. Distributed through Natural Heritage Books.

Starkell, Don, *Paddle to the Amazon.* Toronto: McClelland & Stewart, 1988.

Tatley, Richard, *Northern Steamboats: Timiskaming, Nipissing & Abitibi.* Erin, ON: The Boston Mills Press, 1996.

Wardwell, Walter, *Chiropractic: History and Evolution of a New Profession.* Philadelphia, PA: The C.V. Mosby Company, 1993.

Rushbrook Family Resources

Beard, Ruth (Rushbrook), Personal communication with the author, August 2006-March 2007.

"Rushbrook Family," Personal communications: letters, postcards, notes. Unpublished, 1897–1950.

Rushbrook, John Ernest, "Personal Diary," 1910.

_____, and Frank Sherman, "French River Trip Logs," 1912, 1913, 1916, 1927.

_____, Walter F., *The Prince Rupert Coast Mission.* London, UK: H.B. Skinner & Company, 1928.

Rushbrook, Walter F., Letter to Mr. Hume, March 25, 1950.

Rushbrook Parish Registers 1567–1850. Woodbridge, Suffolk, England: George Booth Company, 1903.

Web Sites Consulted

http://www.civilization.ca, accessed Nov. 22, 2006; Feb. 3, 2007
http://www.hbc.com/hbcheritage, accessed Nov. 27, 2006
http://www.metisnation.org, accessed Nov. 27, 2006
http://www.collectionscanada.ca, accessed Nov. 30, 2006; Feb. 8, 2007
http://www.britannica.com, accessed Dec. 1, 2006
http://www.nps.gov/miss/historyculture, accessed Dec. 3, 2006

http://www.canoekayak.com, accessed Dec. 3, 2006

http://www.chipublib.org/greatfire, accessed Dec. 3, 2006

http://www.canadianconnection.com, accessed Dec. 12, 2006

http://www.thecanadianencyclopedia.com, accessed Dec. 12, 2006; Feb. 8,
 2007

http://www.biographi.ca, accessed Dec. 12, 2006

http://www.parrysound.com, accessed Dec. 13, 2006; Feb. 8, 2007

http://www.historyoftoronto.ca, accessed Dec. 19, 2006

http://www.frenchriver.ca, accessed Dec. 20, 2006; Feb. 8, 2007

http://www.discoverlivesteam.com, accessed Jan. 2, 2007

http://www.torontotourism.com/DistilleryHistoricDistrict, accessed Jan. 2,
 2007

http://www.toronto.com/hotels, accessed Jan. 2, 2007

http://www.genforum.genealogy.com/rushbrook, accessed Jan. 2, 2007

http://www.torontoparks.ca, accessed Jan. 12, 2007

http://www.oklahoma.gov, accessed Jan. 22, 2007

http://www.canadianarchaeology.com, accessed Jan. 22, 2007; Feb. 1, 2007

http://www.tomthomson.org/groupseven, accessed on Jan. 27, 2007

http://www.metisnation.org, accessed Feb. 3, 2007

http://www.chipublib.org/greatfire, accessed Feb. 3, 2007

http://www.canoemuseum.net, accessed Feb. 8, 2007

http://www.ontarioparks.com, accessed Feb. 14, 2007

http://www.northernontario.org, accessed Feb. 14, 2007

http://www.ontarionorth.net, accessed Feb. 19, 2007

http://www.leonardo-davinci.org, accessed Feb. 23, 2007

http://www.frenchriverresorts.com, accessed Feb. 23, 2007

Index

About the Author

The author and his grandson Seamus O. Kelly.

Wayne Kelly was born in London, Ontario, in 1947 He is the author of *Downright Upright: A History of the Canadian Piano Industry,* nominated for a Governor General's Literary Award in 1991 published by Natural Heritage Books. Wayne is also known internationally as "Mr. Crokinole." Having written books and countless newspaper and magazine articles relating to the history of board and parlour games, his 1988 Canadian 'bestseller' *The Crokinole Book* is still in print and in constant demand by game aficionados around the world.

Wayne has co-produced, composed music and written for several film documentaries and has been a frequent guest on national radio and television programs. He is working on two more books that will focus on aspects of Canadian social history, and a wilderness travel guide for Chinese eco-tourists that will be published in the Chinese language.

Wayne and his wife, Jeannie, live in Stratford, Ontario. They have five adult children and four grandchildren. Having spent almost forty years canoeing, camping and hiking together, the Kellys have a particular fondness and attachment to Algonquin Provincial Park. Jeannie is the great-granddaughter of Alexander Kirkwood, who originated the idea of a "National Forest Park" in the Algonquin region in 1885. She is also a descendant of Alexander Mackenzie, the Scottish explorer who became the first European to cross the North American continent by canoe in 1793. Wayne's emotion for Algonquin has been lifelong. His parents spent their honeymoon camped in the park in 1946. Wayne and Jeannie have also done numerous canoe and boating trips through the French River and Nipissing waterways. Shown above, the author and his grandson, Seamus O. Kelly, enjoy the first open water of March 2007, in Perth County's Avon River.